THE
PERFECT
PHOTOGRAPH

THE
PERFECT
PHOTOGRAPH

by Andreas Feininger

AMPHOTO
American Photographic Book Publishing Company, Inc.
GARDEN CITY, NEW YORK

Second Printing, 1978

Copyright © 1974 by Andreas Feininger.
ISBN 0-8174-0565-8

Published in Garden City, N.Y., by American Photographic Book Publishing Co., Inc.

Library of Congress Catalog Card Number-73-92420
Printed in the United States of America.

Table of Contents

6

7

Author's Note: Readers who already own one or more of my books will find that, in the following, certain passages sound familiar. Unfortunately, in the interest of a complete treatment of the subject with which we are here concerned, this kind of duplication is unavoidable. I have, however, held such repetitions to a minimum, referring the reader instead to the book where the point is treated more thoroughly.

Dear Reader...

The Perfect Photograph is the concluding volume in the Feininger-Amphoto Series (published in Great Britain by Thames and Hudson). Unlike the preceding volumes, all of which dealt with specific aspects of photography, such as color, composition, and darkroom techniques, the present book is a summing-up, bringing together all the various factors that contribute, each in its own way, to the final impression of a photograph—whether it will be good, bad, or indifferent.

To call this book *The Perfect Photograph* may at first seem presumptuous, for perfection, in photography or anywhere else, is an elusive something, an ideal. But without ideals for which to strive, life would be unbearable. Ideals give us something to aim for, a standard of excellence by which to judge our work and gauge what progress we have made in our chosen field. Ideals relate to fundamentals, and no matter how complex, controversial, or elusive the qualities that make a photograph good, they go back to fundamental concepts. Sooner or later, any ambitious photographer will have to come to grips with these concepts and clarify for himself the fundamental qualities which, in his opinion, make a photograph good. To give the reader a foundation on which to build his own philosophy of photography was my reason for writing this book.

The complexity of this task is perhaps best illustrated by a brief conversation between two people that I once happened to overhear at a photoexhibition. First person: "I really like this picture." Second person: "I don't." The seemingly unbridgeable chasm of opinion revealed by this dialogue should perhaps have discouraged me from ever attempting to write this book. Instead, it provided the spark that got me started. I said to myself: Are there really no universal criteria by which to judge the value of a photograph? Or are differences of opinion like those I had just witnessed merely the result of lack of subject interest on the part of a specific viewer, of prejudice in regard to certain aspects of the photograph, or of something that has nothing

to do with photography? Why not make a study of the entire complex of value and appreciation in photography, beginning with fundamental concepts? Perhaps, in due course, I might even find the answers to two fundamental questions:

Which are the qualities that make a photograph good?
How does one make good photographs?

I wrote this book assuming that the reader is familiar with standard photographic procedures. However, readers who wish to inform themselves more thoroughly about specific photographic problems can probably find the answer in one of the books by this author listed below. Specifically, for information on general photographic practices, I recommend the following titles published in Great Britain by Thames and Hudson:

The Complete Photographer (344 pages)

For problems related to color photography I suggest you consult:

Basic Colour Photography (128 pages)
The Complete Colour Photographer (408 pages)

The whole complex of darkroom work—organization, installation, equipment, film development, contact printing, enlarging, and basic photochemistry—is treated in:

Darkroom Techniques, Vols. I and II (144, 160 pages)

If the desired information concerns negative or print control, it can probably be found in:

A Manual of Advanced Photography (356 pages)

And if the reader would like to know more about the pictorial and aesthetic aspects of photography, the following two volumes should be of interest to him:

Principles of Composition in Photography (136 pages)
Photographic Seeing (184 pages)

10

I. Fundamental Concepts

The most fundamental assumption in photography—and probably the only one with which everyone agrees—is that every photographer's ambition is to make good photographs. This has led many people to believe that, in order to become good photographers, all they have to do is establish standards for the qualities that make a photograph good, and then learn to produce the necessary effects.

Needless to say, although theoretically sound, this proposition is not likely to work in practice, for one good reason: No two photographers, or for that matter two people concerned with photography, will ever completely agree on what characteristics make a photograph good. Qualities esteemed by some are likely to be derided by others, and vice versa. How then can anybody be so daring (or naive) and try to write a book on how to make good photographs?

If I still make this perhaps foolhardy attempt, it is with the understanding that everything I say is only an opinion—the outcome of some thirty-five years of practical experience in photography. In essence, I am going to give the reader the benefit of everything I have learned in regard to making effective photographs. Then it is up to him to make the most of it.

What makes writing a book on the abstract values in photography so difficult is that, as I said above, no two photographers are likely to agree on all the requirements that a perfect photograph must meet. There are no universally accepted standards of excellence. Unlike bowling and shooting, fields of endeavor in which it is possible to achieve a perfect score, no rules exist to guide a photographer and help him measure the level of accomplishment he has reached in his work. Instead, whatever criteria may exist are as vague, elusive, and intangible as the concepts of happiness, truth, and faith. If, therefore, in the following, I am not always as specific as desirable, I beg the indulgence of the reader, who cannot just sit down, relax, read this book, memorize a set of rules, and rise a better photographer. Instead,

he must try to follow my arguments, critically consider what I say, draw his own conclusions, modify my suggestions to fit his own personality and type of work, and end up, if not necessarily a better photographer, at least a more thoughtful one.

However, I don't want this cautious outlook to be construed to mean that I don't believe in the existence of perfect photographs. In my opinion, there are classics in photography that are tantamount to perfection. Here are some examples with which the reader is probably familiar: Stieglitz's photograph *The Steerage;* Edward Weston's *Cabbage Leaf* and *Pepper* series; the famous photograph of the Iwo Jima *Flag-Raising* by Joe Rosenthal; Kyoichi Sawada's moving shot of a *Vietnamese Mother Fleeing with Her Children,* to name only a few that immediately come to mind. And without having to worry about appearing presumptuous, every photographer can doubtless add examples of his own work that, as far as he is concerned, are perfect. I believe that my photographs *Midtown Manhattan Seen across the Hudson, Navy Helicopter Take-off at Night,* and *Photo-Journalist* come as close to perfection as I can ever hope to get. So there is hope—provided we are successful in pinning down, analyzing, and making use of those elusive qualities that make a photograph good.

In my opinion, one of the most basic concepts in photography is the fact that any photograph represents a

synthesis of technique and art.

Unfortunately, many people, photographers and nonphotographers alike, are not sufficiently aware of this. Although they realize that a photograph that is technically inadequate—fuzzy where it should be sharp, off color, grainy instead of smooth, too flat or too contrasty, and so on—cannot possibly qualify as good, they fail to appreciate the contribution of art. As long as the technical execution of the picture is unassailable, they will consider it good, no matter how meaningless the subject, how trite, confused, and artistically inadequate the form of presentation. In other words, while they realize the importance of *phototechnical* excellence, they fail to see the necessity for an *artistically* satisfying impression. Proof that this is true can be found in the countless photo contests that award prizes to pictures that are of hackneyed subjects, were badly seen by the photographer, and are devoid of artistic merit—the typical photographic clichés. But the fact that these pictures were flawlessly executed as far as phototechnical standards are concerned impressed the judges to such a degree that

they overlooked their glaring artistic deficiencies. This observation led me to my first conclusion regarding the making of good photographs:

A photograph can be good only if it satisfies both artistic and phototechnical demands.

I'd like to elaborate on this principle by drawing a parallel between photography and music. What is the most important criterion in music? Obviously, the concept of the work, the merit of the score, the music itself, the effect of the *composer's* work on the audience. In other words, *artistic* qualities. However, before these artistic qualities can be enjoyed by anyone, the music must be played. An idea has to be given tangible form. This is done by musicians, skilled performers who, with the aid of musical instruments, give an inspiring, adequate, or disappointing performance.

What I wish to get across is this: As long as the work itself has artistic merit, intrinsic values have been created that even poor execution cannot destroy. At another performance by a better orchestra, the inherent beauty of the music will be revealed, and the work will be a success. But if the work itself is artistically inadequate, not even the most accomplished musicians using the finest instruments to give a technically flawless performance can make the music sound good.

The lesson photographers can learn from this analogy seems obvious to me. In photography, too, a creative person conceives an idea for a picture, which must be given tangible form before it can be enjoyed by anyone. The means is not a musical instrument, but rather the camera, lens, and enlarger, used with a greater or lesser degree of skill. If the concept of the photograph is good—an interesting subject interestingly seen—not even a technically poor execution can destroy the picture's value entirely. The subject interest will still be there and the picture will speak, even though the message may be formulated clumsily. But if a better print is made by a more accomplished darkroom technician, perhaps the cropping changed, then the merit of the concept will come through; the message will be loud and clear. If, on the other hand, the concept of a photograph is poor, or if the picture has nothing to say, not even an expert phototechnician using the finest equipment and latest techniques can make it look good, because, in photography,

technique is nothing unless complemented by art.

This duality, of course, is inherent in any field of creative expression. It manifests itself at two levels:

The level of creation
The level of execution

First, there is the moment of insight, the flash of inspiration, the idea. Then follows the problem of execution, of how to give a mental concept tangible form. Altogether, a four-part sequence is involved, which, as far as a photographer is concerned, can be expressed as follows:

The idea—the mental concept of the picture;
the technical means of execution—camera, film, and so on;
the skill required to use the technical means; and
the final, tangible result—the transparency or print.

Conclusion. Only if a good idea is expressed in a technically competent form of execution can the resulting photograph be good.

II. The Purpose of Photography

Like painting or drawing, photography is a form of visual communication. Few people take pictures merely to please themselves. The overwhelming majority of photographers want their pictures seen by other people with whom, for a variety of reasons, they wish to communicate through their photographs. Consequently, the purpose of any photograph is twofold: general and specific. The general purpose is communication; the specific purpose is the particular reason the photograph was made.

In order to qualify as good, anything created for any purpose must fulfill the intentions and expectations of its maker. This applies no matter whether the thing in question is a racing car, a radio, a book, or a photograph. Accordingly, a further conclusion in regard to making good photographs can now be drawn:

A photograph can be good only if it fulfills its purpose.

The next question in our search for the qualities that make a photograph good must therefore be: How can I assure that my photograph will fulfill its purpose?

As stated above, photography is a form of visual communication. Please pay particular attention to these two words, visual and communication, because they contain important clues for the making of better photographs.

ASPECTS OF VISUALIZATION

A photograph can fulfill its purpose only if it is brought to the attention of its intended viewer. Unfortunately, nowadays people are so sated with visual images, which intrude on them continually from all sides—TV and movie screens, billboards, newspapers, magazines,

books, subway and bus advertising—that they notice consciously only those images that force themselves on their attention; the rest they ignore. Now, an ignored photograph obviously has failed in its purpose, which is to communicate with a viewer and relate to him its message. A prime requirement of any good photograph is that it be noticed. It must, therefore, be noteworthy. This presupposes eye appeal, or visual stopping power, specific graphic qualities that aggressively attract a potential viewer's attention. The fact that a photograph is visible, *i.e.*, displayed in a magazine, an exhibition, a book, is not enough to assure its being noticed; to make a *conscious* impression, it must be visually appealing. How a photographer can instill this quality into his pictures will be discussed later (pp. 124–127). Here, we can add another rule for making good photographs:

In order to qualify as good, a photograph must have eye appeal.

ASPECTS OF COMMUNICATION

As a means of communication, a photograph must, of course, have something to say, something that is worth communicating. More specifically, the picture must show something that is of interest to the intended viewer, that tells him something he might like to know, something that informs, entertains, or amuses him, stimulates his mind, makes him think or feel. Because of the importance of this particular picture quality, which constitutes the meaning or the message of the photograph, I'll come back to it later in more detail (pp. 119–122); here, we can write down still another requirement for making good photographs:

A photograph can be good only if it has something worthwhile to say.

Although this principle applies to any photograph, in practice it needs further refinement. "Something worthwhile to say"—precisely what does that mean? Who is going to judge whether or not what my photograph says is worthwhile? Two people: I, the photographer, and the viewer for whom the picture was made.

This is the moment—and there will be others—where the going is bound to be vague. Because the worthiness of one photographer or viewer is bound to be the childish nonsense or offended outrage of

16

another. Later (pp. 119–122), I'll come back once more to the subject of meaning in photography and try to be more specific. Here, all I want to do is alert the reader to the importance of the concept of message in photography; then it is up to him to decide what his message should be.

The importance of purpose, message, and meaning in judging the value of a photograph is perhaps best illustrated with the aid of an actual experience of mine. At a photographic exhibition, one picture caught my attention because it was so unbelievably dull. The subject was a landscape on Cape Cod consisting of nothing but a level stretch of sand under a uniformly overcast sky, with the horizon in the very center, dividing the view into equal parts. Overall contrast was low, graininess high, and subject matter virtually nonexistent, the only points of interest being two clumps of dune grass. In short, the picture violated just about every academic photographic rule; at the same time, it had an indefinable, yet compelling quality that captured and held my attention. But I didn't know what to make of it, and just as I was about to turn away and dismiss it as inconsequential, the lightning of insight struck me, and I understood. The message of this picture was solitude, its purpose to give an impression of the boundless expanse of the beach, the monotony of earth and sea and sky stretching to infinity. Its deliberately low contrast and grainy grays brought to mind drizzly November days when harsh northeasterly winds rake the empty beaches and veils of mist and driving scud create a mood of desolate monotony. This, then, was the reason for the monotonous form of rendition that the photographer had chosen deliberately to get across his message. He had succeeded splendidly. Which prompts me to add here another rule by which an intelligent photographer should live:

Don't judge a photograph until you are sure you understand what the photographer wanted to say. Otherwise, you may be unfair to the photograph, the photographer, and last but not least yourself, because you might miss something that could have enriched your life if only you had understood.

The need for understanding the intent of the photographer and the purpose of the picture before trying to evaluate it in terms of failure or success should be obvious to anyone who realizes that the criteria for judging depend on the specific situation; a scientific-documentary photograph, say, must be judged differently from a still life, an abstraction, or a nude. In the first case, prime consideration must be given to qualities like clarity and informative value; in the other cases,

graphic, aesthetic, artistic, and imaginative aspects take precedence. In scientific photography, an imaginative subject treatment might lead to confusion; conversely, the scientific-documentary treatment of a nude would unquestionably produce a boring, even ugly picture.

Accordingly, a photographer planning a scientific-documentary photograph must think primarily in terms of clarity and informative values, taking an objective approach to his subject. Conversely, a photographer contemplating the shot of a nude must give his imagination free rein and try to make the picture reflect, not the clinical view of the undressed human body, but what he felt in its presence. All of which goes to show that, except for grab shots and lucky accidents, the making of any photograph should start with the photographer defining the purpose of his intended picture. Precisely what does he want it to say? What does he wish to accomplish? The foundation for success or failure is laid before the exposure is made, while there is still time for changes. Afterwards, the die is cast, for better or worse, and all that subsequently can be done to influence the effect of the picture is relatively inconsequential.

The more precisely defined the purpose and message of a contemplated picture, the better its chance for success.

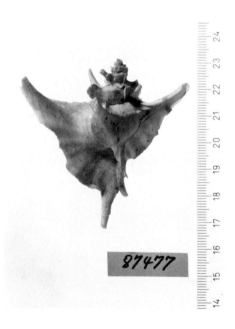

The purpose of the picture plays an important role in deciding whether or not it deserves to be called a "perfect photograph." Shown here are two versions of the same subject. Despite obvious differences, in its own way, each is a "perfect photograph."

18

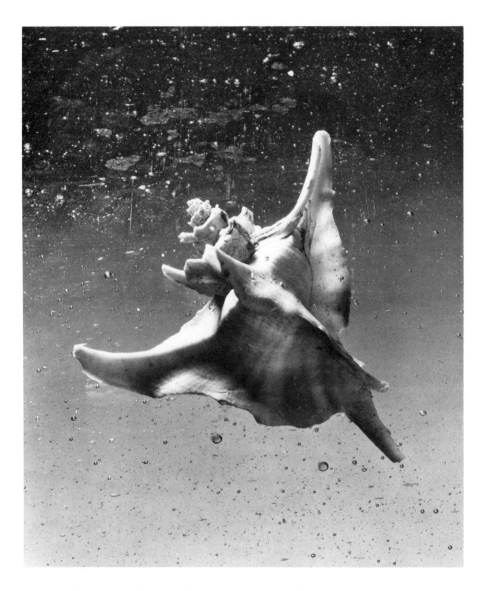

Left: An objective rendition (p. 22) intended for scientific purposes. Neutral, shadowless background and low-contrast illumination for full detail rendition insure a maximum of clarity; the specimen's collection number and the centimeter scale provide important means of identification.

Above: A subjective rendition (p. 22) intended to make the subject appear attractive to the layman. "Scaleless" presentation, an interesting and suggestive background, and high-contrast illumination combine to give the picture graphic appeal. Both photographs were made by the author and are taken from his book *Shells* (Thames and Hudson, 1972).

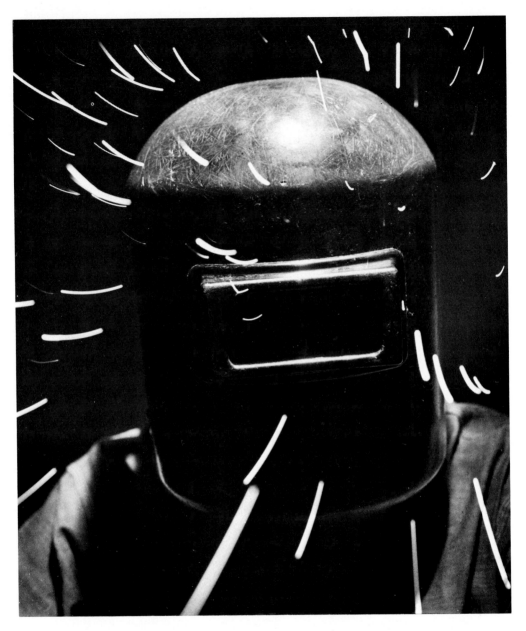

Arc welder, by *Andreas Feininger.* The pattern of flying sparks is no "lucky accident." To achieve what I had in mind, I made the picture in two parts—a shot of the welder sandwiched with a shot of the sparks. The welder was easy, a simple matter of lighting. But to get the pattern of sparks I had to shoot two rolls of film before I got the perfect design.

20

III. The Scope of Photography

Since a photograph is a means of communication, it must not only have something to say, but should also say it well. The more clearly formulated the message of the picture and the more elegantly expressed, the better the photograph.

Nowadays, of course, anything can be photographed. To deal effectively with this immense variety of potential subjects, a whole arsenal of different and sometimes highly sophisticated photographic instruments and techniques has been developed and is at the disposal of any photographer who wishes to avail himself of these means, these aids for making better pictures.

Unfortunately, many photographers still fail to utilize, or utilize only incompletely, the full scope of these means, which properly used could help them raise the standard of their work. They overlook or are not aware of the fact that every photograph is a puzzle that can yield a perfect picture only if all its parts fit together harmoniously: the subject—the form of its rendition; the photographic equipment used to implement the chosen form of rendition; the skill with which this equipment is used; and the expertise of the person who develops the film and prints the negative. Since the interrelationship and integration of these factors plays a vitally important role in deciding the effect of any photograph, it will be the subject of a later chapter. Therefore, I can be brief here and limit myself to a summary of the main factors involved. My objective is to alert the reader to the possibility of *choice*, the fact that there are always several ways of accomplishing a specific goal, some of which may be better than others. Experienced photographers exercise this privilege of choice right from the start, the moment they contemplate making a picture, by choosing between two different forms of photography:

Objective photography
Subjective photography

OBJECTIVE PHOTOGRAPHY

Objective photography deals with realities. The purpose of this form of rendition is to present facts in picture form. Accordingly, the photographer must make a conscious effort to prevent whatever bias or personal feelings he may experience in the presence of his subject from showing in his work. This, of course, does not mean that an objective photograph must be dry and dull. On the contrary, a graphically artistic form of rendition is bound to increase the informative value of such pictures by excluding superfluous subject matter, improving the composition, and rendering the subject itself in a tightened and therefore more effective form.

Prime considerations are clarity, simplicity, directness of approach, and concentration on essential features of the subject. Imagination can be a valuable aid in finding new and more effective forms of rendition but must not be carried to the point where, by injecting the subjective view of the photographer, it would interfere with the facts of the picture. This is the approach of the scientist, the documentary maker, the illustrator of textbooks and manuals, and anyone who uses photography for purposes of recording, cataloguing or, in the form of photographic sketches, as an aid to memory.

SUBJECTIVE PHOTOGRAPHY

Subjective photography deals with feelings. The purpose of this kind of picture is to present not so much what the photographer saw as what he felt in the presence of his subject. Here, facts are subordinate to reactions, opinions, and personal views, and the subject is less important than the form in which it is seen, captured, and presented.

Prime consideration is a genuine understanding of and feeling for the subject. Imagination is all-important as a guide to effective rendition. It will often make use of such unorthodox means as distortion, superimposition, unsharpness, solarization, reticulation, the bas-relief process, and cylindrical or spherical perspective.

This is the approach of the artist, the poet, the dreamer, the photographer who feels strongly about his subject, who wants to share his feelings with other people and convert them to his point of view. As a result, subjective photographs sometimes reveal more about the

photographer himself than about the subject, and can remain mysterious and even difficult, if not impossible, to understand—characteristics which this form of photographic rendition shares with certain works of modern art. In comparison with the objective subject approach, subjective photographs are generally more stimulating, because they present the subject in a new and unfamiliar form, giving the viewer an unusual visual experience and, if the photographer is successful, a new awareness and insight.

THE PRIVILEGE OF CHOICE

Amateurs who complain that professional photographers get all the breaks are reminded of the fact that theirs is a priceless position not shared by any professional: *They have no boss;* no client breathing down their neck, no editor to satisfy, no art director telling them what to shoot and how to shoot it. They are completely free to do whatever they please; theirs is the privilege of choice.

Amateurs are free to choose their subjects, their equipment, their techniques. They are free to wait until conditions are right for a shot instead of having to compromise because "time is money" or deadlines have to be met; free to come and go, to work or not to work, to photograph today, tomorrow, or next week. On the other hand, they alone are responsible for their work, and if their pictures are not up to expectations, they have nobody to blame but themselves. And many times they fail *because* they did not exercise their privilege of choice.

Any subject can be photographed in a literally unlimited number of different forms. Each form will give a different impression of the subject, show it from a different angle or in a different light, literally as well as figuratively. Most of the necessary devices and techniques are familiar to most photographers, but they forget to use them when they are most needed. As an aid to memory, here is a brief run-down of those that are readily available to the average photographer who does not want to invest in costly equipment.

Distance between subject and camera

You have the choice between long shot, medium-long shot, and closeup. The first shows the subject in relation to its surroundings; the second results in an average view; and the third produces a more

intimate form of rendition, with emphasis on detail. Remember, in this connection, that perhaps the commonest of all photographic mistakes is to stay away too far from the subject. Consequently, subjects appear in the pictures too small to be effective. The closeup, where the subject fills the entire frame of the picture, is the most powerful form of rendition.

Direction of view

You have the choice of showing your subject in frontal, side, or rear view; with the camera pointing horizontally, more or less upward or downward, or seeing the subject from below (worm's-eye view) or above (bird's-eye view). Plus an unlimited number of intermediate positions.

Each time you take a step in one direction or another, or raise or lower your lens, you see your subject from a new angle and in a different perspective, and you also change the relationship among subject, background, and foreground. This gives you a chance to control the arrangement of the various picture components relative to one another, eliminate disturbing background elements, avoid unwanted perspective distortion, and take corrective measures designed to strengthen the composition. Remember: Rarely is the first view of a potential subject the best, because further investigation will probably reveal a better one. Only beginners don't care about the form in which their subject appears in the picture as long as it appears.

Time of day

Outdoors, it makes a great difference whether you photograph early in the morning, during the middle of the day, in the afternoon, around sunset, or at night. In photographic terms, these differences manifest themselves primarily in two respects: the extent and direction of the shadows, and the color of the light. The latter is an important consideration in color photography: Early and late daylight is warmer —more toward yellow and red—than light during the middle of the day, which on a sunny day is white; light at dusk and at night is blue.

Experienced photographers are well aware of such distinctions and use them creatively. They take pictures early or late in the day to exploit the longer shadows, avoid shooting around noon in harsh overhead light, and utilize the different colors of daylight to produce unusual effects.

(Text continued on p. 46)

You always have a CHOICE. . . .

Except for "lucky accidents", good photographs are the result of planning, technical know-how, and a talent for making the right CHOICE among the virtually unlimited number of different ways in which any subject can be presented in photographic form.

The following 20 pages contain 12 series of photographs, each series showing the same subject rendered in two or more different forms. In each case, one basic photographic aspect was varied while most or all of the others remained the same. The purpose of these "photographic finger exercises" is to make the reader aware of the fact that he always has a CHOICE between different possibilities, some of which are bound to be more effective than others; that the first impression of a potential photographic subject is not necessarily the best one; and that the photographer who deliberately explores his subject most fully is the one most likely to bring home the "perfect photograph."

All the pictures on pp. 26-45 were made in accordance with my instructions by *John Veltri,* a talented young photographer who has collaborated with me on previous occasions and whose work again contributes to making this book more informative than it would have been without his valuable help.

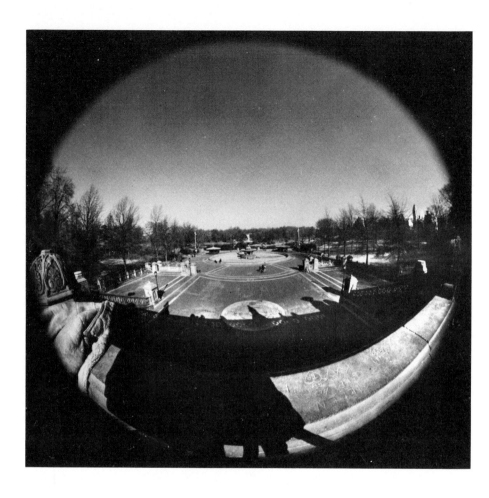

Subject scale and angle of view are functions of the focal length of the lens. Consequently, by using a lens with a shorter or longer focal length, a photographer can at will show his subject in smaller or larger scale—in the context of its surroundings (overall view) or in the form of a closeup or, of course, in any intermediary form—and include in his picture a wider or narrower angle of view.

The photograph at the top of the page was made with a 7.5mm fish-eye lens on 35mm film; the pictures on the opposite page were made with lenses of 20, 105, and 300mm focal length, respectively. All were taken from the same camera position—convincing proof of the degree of control which a photographer has over the spatial appearance of his picture.

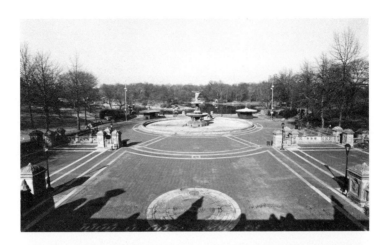

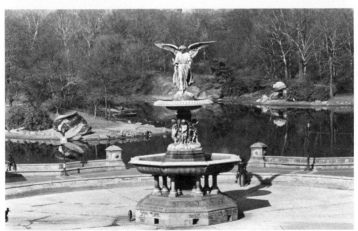

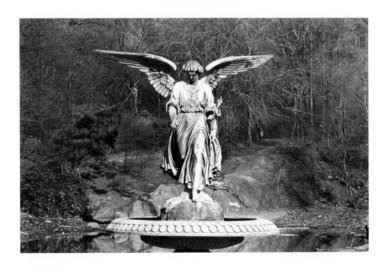

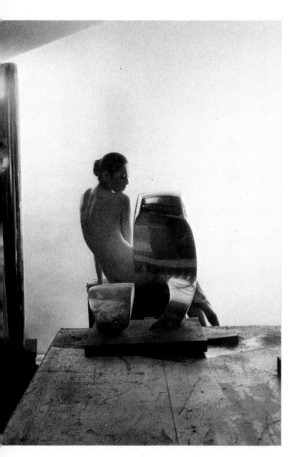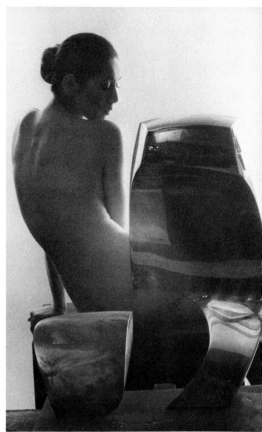

Subject scale and perspective are controlled by the *distance* between subject and camera in conjunction with the *focal length* of the lens. Consequently, through appropriate choice of these two factors, a photographer can render his subject in the scale and perspective which suits his purpose best.

The picture pair at the left illustrates *control of subject scale* through focal length of the lens. Both pictures were made from the same camera position, as a result of which their perspectives are identical—in both, the relative proportions, the arrangement, and the overlapping of the sculpture by Roy Gussow and the model are the same. The differences in scale and angle of view are due to the fact that the left picture was made with a short-focus or wide-angle lens, the right one with a long-focus or telephoto lens. But if we would enlarge the

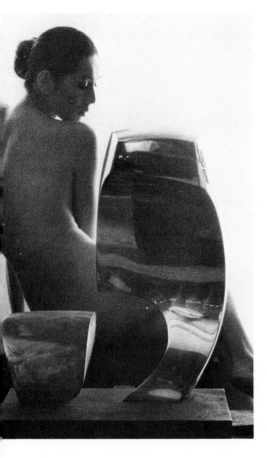
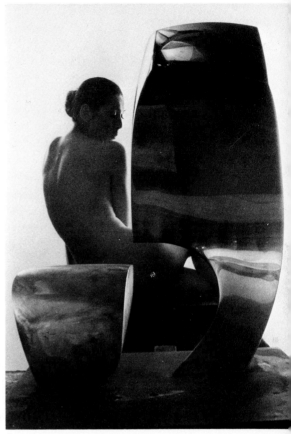

subject of the first picture to the scale of the second picture, we would find that the perspectives of both are identical and, if superimposed, the two pictures would register perfectly.

The picture pair at the right illustrates *control of perspective* through variations in subject-to-camera distance in conjunction with the use of lenses of different focal lengths. The left picture was made with a long-focus lens from relatively far away, the right one with a short-focus lens from close-up. Although the distance between girl and sculpture was the same in both cases, in the first photograph the girl is rendered larger than the sculpture, while in the second picture the sculpture is rendered larger than the girl. Any intermediary form of scale-relationship could, of course, have been produced, too.

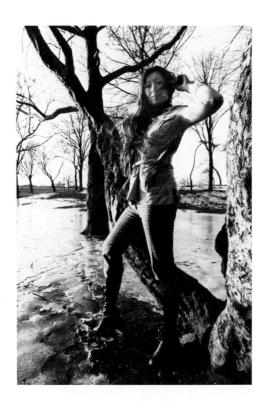
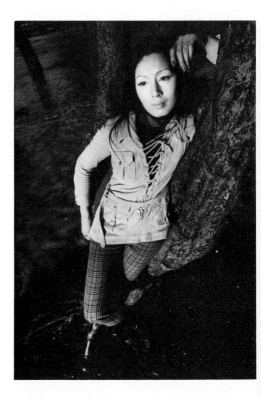

Subject scale and direction of view are determined by the *distance* between subject and camera in conjunction with the *angle of approach*. Since these two factors can be varied infinitely, any subject can be photographed in an infinite number of different ways.

The pictures on these two pages show how a creative photographer tries to narrow down the infinite possibilities to a few promising attempts. In this respect, success or failure depend on how well the photographer can make use of the factors with which he has to work, the most important ones of which are: the model, her pictorial qualities, her poses and expressions, her clothes; his camera, lenses, filters, film, etc.; the direction and quality of the ambient light; the immediate surroundings; the background. Only if all these components are integrated into a harmonious whole can the result be a "perfect photograph."

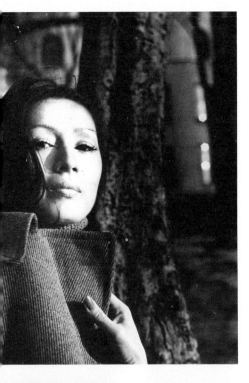
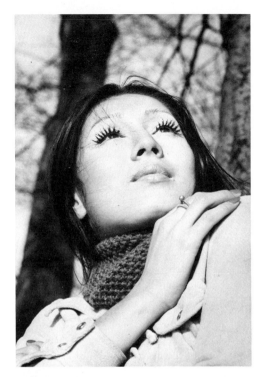
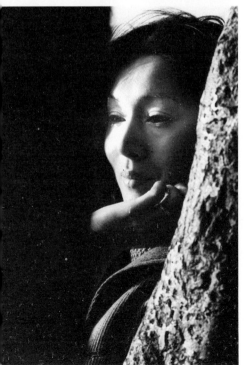
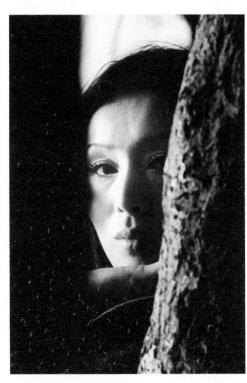

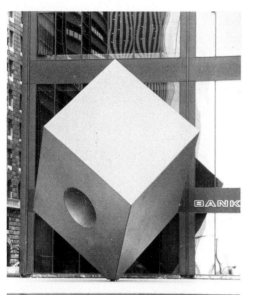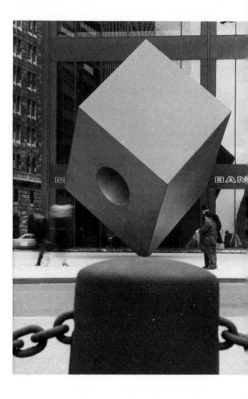

A "photographic finger exercise". *Experience makes the master* is an old saw that is as valid in photography as anywhere else. And since there is no substitute for experience, I strongly urge the reader to find a suitable subject (like the modern sculpture in these photographs) and study it from all sides and in different kinds of light. The fact that, photographically, this cube is rather dull makes the assignment all the more challenging. Specifically, study the interplay of light and dark on the different faces of the cube; the hole experienced as a circle and as a cylinder; the relationship between the cube, its surroundings, its background; the buildings that form the background in regard to perspective (parallel or converging verticals), design (the pattern of the windows), and tonal shades (light or dark); the "static" cube in relation to the "dynamic" traffic around it. Notice that the first picture in this series makes a beautiful "static" design, the last one a compelling "dynamic" composition.

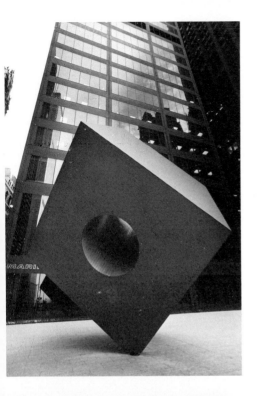
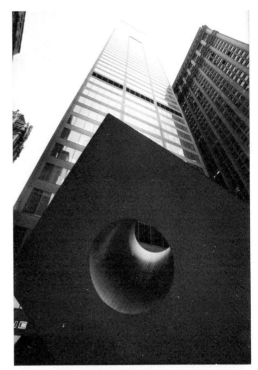
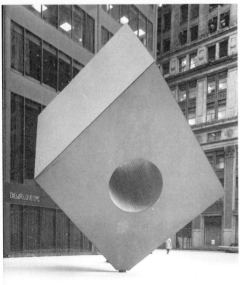
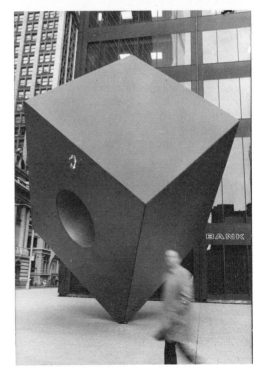

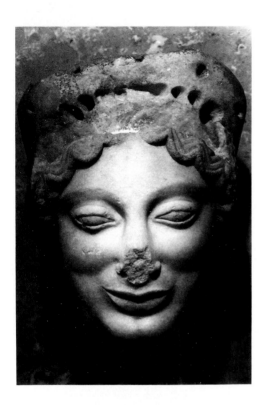 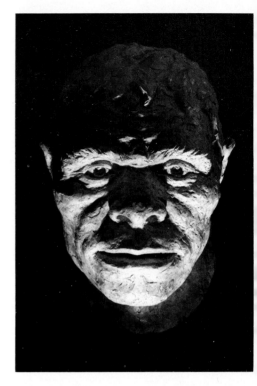

Light is the photographer's medium, and mastery of light and lighting is a prerequisite for the production of "perfect photographs." Therefore, I suggest that the reader not only study in detail the pictures on this spread, but perform similar tests in order to familiarize himself with the characteristics of the different forms of light.

Above: Toplight *(left)* and light from below *(right),* two forms of light which are rarely used in this pure form. Notice in particular the extent and precise location of the shadows around the eyes and lips and their effect upon the modulation and expression of the face.

Opposite, top left: Frontlight produces virtually shadowless illumination. *Top right:* Three-quarter top-and-side-light yields excellent modulation; this is one of the most popular forms of portrait light. *Bottom left:* Sidelight produces interesting, powerful, and unusual effects. *Bottom right:* Backlight is moody, stark, and difficult to use but capable of yielding some of the pictorially most interesting results.

34

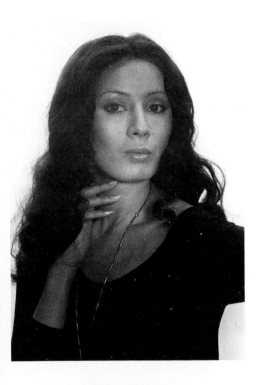
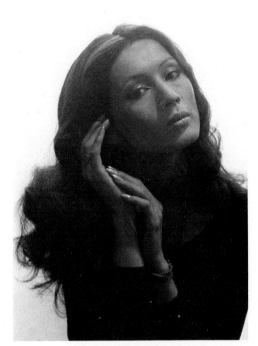
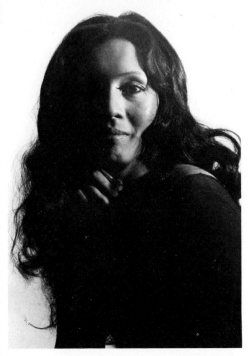
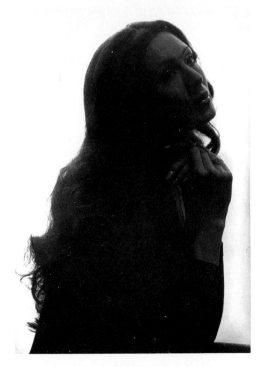

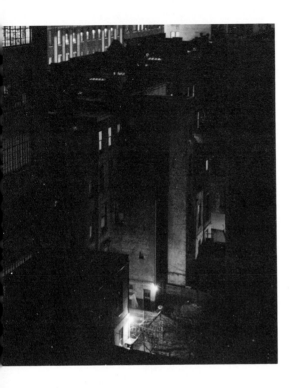 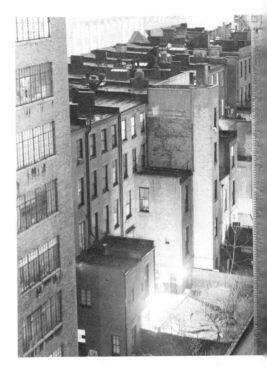

Light is malleable, and the ability to modify light is one of the prerequisites for making "perfect photographs."

Above: Two versions of the same night scene—*left,* as it appeared to the eye; *right,* as rendered by a prolonged time-exposure. Which one is "better" depends on how much detail a photographer intends to show, with all the intermediate states at his disposal.

Opposite: Direct light *(top left)* and diffused light *(top right).* The difference is subtle but consequential: direct light is documentary and matter-of-fact; diffused light is "soft", idealizing, and romantic. Again, the photographer has a CHOICE.

Right: An example of a shadowless illumination—the subject is illuminated evenly from all sides with highly diffused light, in this case, light from several photoflood lamps directed against and reflected by the white walls and ceiling of the studio. This type of illumination is particularly effective in cases like this in which shadows would obscure an already intricate design and create confusion, especially if sufficient contrast is already inherent in the subject.

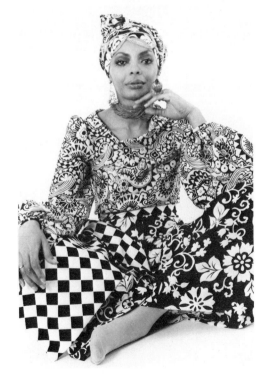

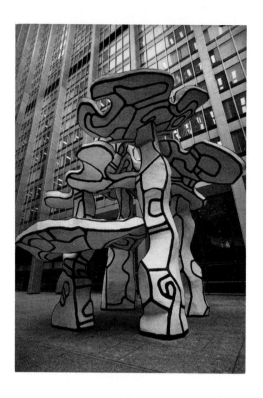
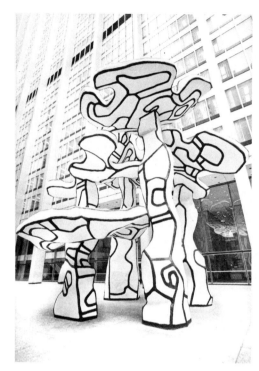

Degrees of lightness and contrast. By varying the print exposure, printing his negatives on paper of softer or harder gradation and, if necessary, combining these two controls, a photographer can influence the graphic and thereby the emotional effect of his picture—a light print leaves an impression that is different from a darker one, a contrasty print affects the viewer differently from a softer one.

Both versions of each pair of pictures shown on this spread were made from the same negative. The differences in lightness, darkness, and contrast were created in the darkroom to show the reader that normally there is no single "best way" of printing a negative. Which form is "best" depends, of course, on the intentions of the photographer, and what is effective in one case may be undesirable in another. The purpose of these "photographic finger exercises" is merely to alert the reader to the possibilities which are at his disposal. Then it is up to him whether or not to use them.

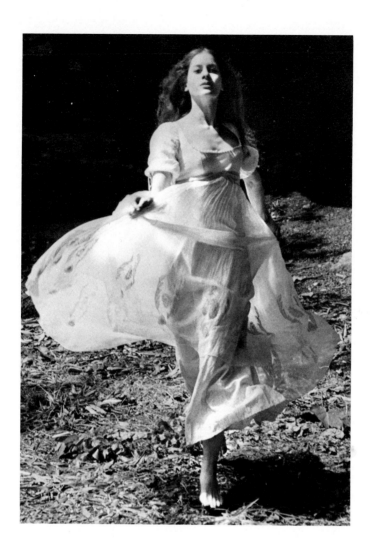

Motion rendition in still-photography. Shown on this spread are examples of the three most effective ways in which motion can be expressed in a still. *Above:* Sharpness can be very effective if the subject is obviously in motion, as in this case where motion is indicated by the swirling folds of the dress. *Opposite, top:* Blur due to subject motion proves that the automobile was moving when this picture was made; had the car been rendered sharply, it would have looked as if it had been standing still. *Opposite, bottom:* Blur due to controlled camera movement ("panning", see p. 58) is an effective motion symbol if a moving subject must appear sharp in the picture; in that case, it is the blurred background which evokes the feeling of motion.

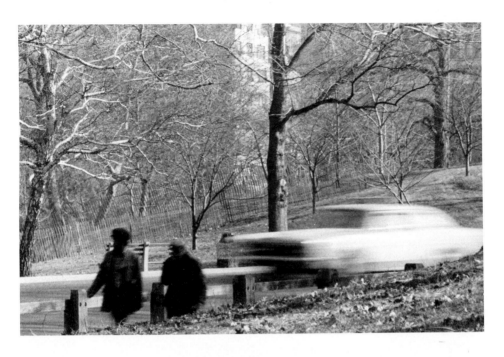

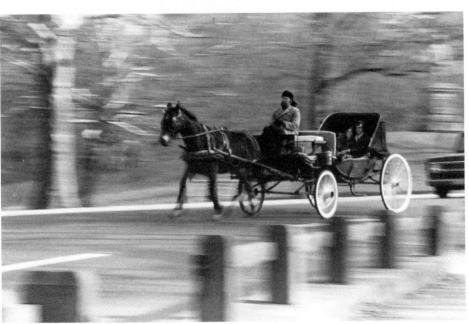

The proportions of the photograph. The fact that normally all the negatives produced by one camera have the same proportions does not mean that all the photographs must have the same proportions, too. Because as easily as the size of a photograph can be changed through enlarging, so its proportions can be changed through cropping.

Experienced photographers make use of this possibility by adjusting the height and width of their pictures in accordance with the character of the subject and the impression they wish to create. Imagine the pictures on this spread in the standard proportions of four to five—and you will realize how much their effect depends on their particular proportions of height to width.

Color transformation into black-and-white.
These photographs are reproductions of the
same color transparency of a red-and-yellow
balloon seen against a bright blue sky. With
the aid of filters ranging from red (top row)
to blue (bottom row), by printing the
negatives on paper of different gradation,
and through appropriate variations in the
time of the print exposure, any combination
from light-balloon-on-light-background to
light-balloon-on-dark-background, and from
dark-balloon-on-light-background to dark-
balloon-on-dark-background could be
achieved.

Which one of these different versions
produces the most "natural" color transfor-
mation? The one in the center, of course,
because it correctly translates colors of
identical brightness (bright red and bright
blue) into identical shades of gray. That the
resulting impression is one of drabness,
which in no way suggests the brightness of
the original scene, is only further proof that
"naturalism" in photography is not neces-
sarily a desirable picture quality, and that
only a creatively *controlled* rendition can
lead to a "perfect photograph."

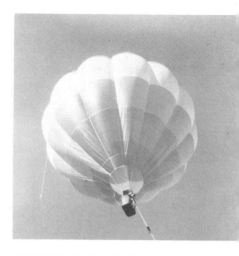

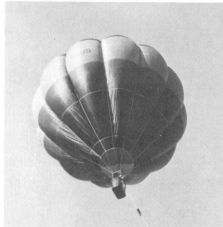

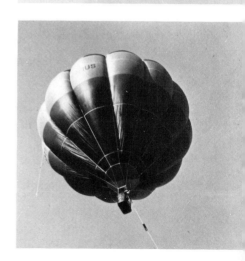

44

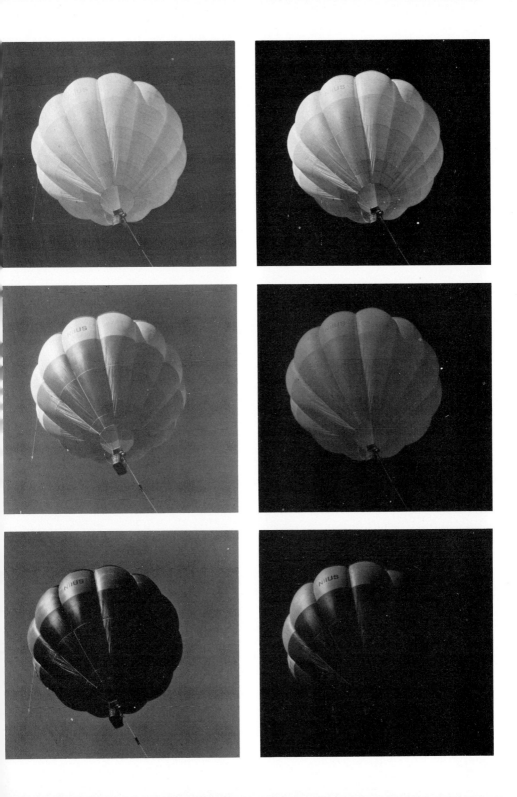

Direction of the incident light

The same subject appears very different, depending on whether it is photographed in frontlight, sidelight, backlight, light from above, or light from below.

Front light gives the best results if accurate color rendition is the prime objective. On the other hand, since the subject appears more or less shadowless in frontal illumination, such pictures seem to lack depth, a fact that can be used to create particularly interesting graphic effects.

Sidelight casts distinct shadows and thereby creates effective illusions of depth. In the form of low skimming light, it emphasizes texture.

Backlight produces higher contrast than light from any other direction, which makes it difficult to use in color photography. On the other hand, skilfully handled, it is potentially the most interesting form of light.

Light from above, the typical noon light of summer, is contrasty and harsh; it easily casts ugly shadows, particularly in portraits. Although beloved by beginners because it is so "nice and bright," experienced photographers shun it.

Light from below, which normally does not occur in nature but can, of course, be produced with the aid of photolamps, leads to weird and theatrical effects that are better avoided, unless specifically called for.

Color of the incident light

Color films are made for use in conjunction with only four types of light: daylight color film for use with standard daylight or electronic flash; Type A color film for use with photoflood lamps of 3400 K; and Type B color film for use with professional tungsten lamps of 3200 K. If film emulsion and type of light don't match, color rendition is bound to appear distorted.

If the color of the incident light does not fit the color film, the photographer can either change the *effective* color of the light with the aid of the appropriate Kodak Color Conversion or Light Balancing Filter, so that the light matches the color for which his film is balanced; or, he can use the abnormal-colored light for the creation of

special effects. In the first case, he will get slides or transparencies in which the subject appears in its natural colors; in the second case, anything goes, the effect depending solely on the expertise and imagination of the photographer.

Type of incident light

Discriminating photographers have the choice between the following types of light, each with its own characteristics:

Direct light casts well-defined shadows, is relatively contrasty, and has the same color as its source, a fact of importance to color photographers but of no consequence to those who work in black-and-white. This type of light gives the best results when a clear and factual rendition is desired or accurate color rendition a prime objective. It is unsurpassed for indicating texture and excellent for creating convincing spatial effects.

Diffused light is relatively soft, is more or less (or, in extreme cases, entirely) shadowless, and has a color which is a blend of that of the light source and its diffuser. Sunlight diffused by a layer of clouds can have almost any color—white, yellowish, reddish, bluish, or purplish—depending on the type of overcast and time of day. Diffused light is particularly effective in portraiture and in subjective photography where mood is more important than fact.

Reflected light is even softer than diffused light. Its color is a mixture of the color of the light source and that of the reflector. Color photographs taken in the open shade on a sunny day, for example, always have a strong blue color cast, the blue sky being the reflector. Color pictures taken indoors with the aid of bounce light (flash reflected from the ceiling) are bound to have a cast the color of the ceiling unless the ceiling is white.

Filtered light has lost part of its original spectrum through absorption by the filter and occurs in two forms: natural and artificial. Common forms of naturally filtered light are sunlight filtered by haze, by a layer of clouds, or by foliage. Artificially filtered light is light passing through colored window glass (whose coloring may be unnoticeable to the eye but very much in evidence in the transparency, since color film is much more sensitive than the eye), or light whose spectral composition was deliberately changed by the photographer with the aid of a color filter. Successful filtration demands a high degree of experience based on carefully controlled tests.

Natural or artificial light

Frequently, a photographer has the choice of photographing his subject by either natural or artificial light. He must be aware of the following characteristics of both types of light:

Natural light, as a rule, provides a more uniform illumination, particularly as far as the relative brightness of subject, background, and foreground is concerned. Since it emanates from a single light source—the sun—it can cast only a single set of shadows. Therefore, its effect is more natural-looking and usually more pleasant than that of an artificial illumination consisting of several light sources, each of which casts its own set of shadows. On the other hand, natural light often changes rather unexpectedly in brightness. Its color is difficult to evaluate unless the conditions for standard daylight prevail. (Standard daylight is a combination of direct sunlight and light reflected from a clear blue sky with some white clouds during the hours when the sun is more than 20 degrees above the horizon.)

Artificial light is much more constant and reliable than natural light, and if incandescent photolamps, flashbulbs, or electronic flash are used, it is easier to predict color rendition; as a result, color photographs made on the appropriate type of film generally show excellent color. On the other hand, since it permits the photographer to employ any number of light sources, each with only a limited effective range, artificial light is considerably more difficult to handle effectively than natural light. Underexposed backgrounds and overexposed foregrounds are common, as are multiple shadows, which may even cross one another, a most unsightly fault of many pictures made by artificial light.

Photographers wishing to work by artificial light have the choice of two basically different forms:

Continuous light is given off by incandescent and fluorescent photolamps. It has the advantage over discontinuous light that the photographer can visually control the distribution of light and shadow in his picture and measure precisely the contrast range of the illumination by taking spot readings of the lightest and darkest subject areas (*exclusive* of black and white). Thereby, he avoids burned-out highlights and backgrounds that are unpleasantly dark. On the other hand, lamps giving off continuous light, besides giving off a large

48

amount of heat, are normally not bright enough to permit exposures sufficiently short to freeze a subject in motion.

Discontinuous light, the alternative, is given off by flashbulbs and electronic flash. It is a cold form of light, but is also bright enough to permit the photographer to freeze virtually any kind of motion, no matter how fast. On the other hand, arranging effective illumination is largely a matter of guesswork, since the photographer cannot normally check the distribution of light and shadow nor can he measure the contrast range. Although large commercial speedlights have built-in modeling lamps and exposure meters for speedlights exist, these items are too expensive to be of interest to the average amateur, who must arrange his illumination blindly and calculate his flash exposures with the aid of the guide numbers provided by the lamp manufacturer.

Angle of view

Depending on whether a shot is made with a wide-angle, a standard, or a telephoto lens, the picture will include a more or less extensive angle of view. This gives the photographer a choice between an overall and a more tightly composed view of his subject, each with its own advantages: The overall version shows the subject in relation to its surroundings; the picture taken with the standard lens represents the type of view that most closely corresponds to what we see in reality; and the telephoto shot presents the subject in the form of a closeup, thereby giving the viewer of the picture a chance to see distant details.

Type of perspective

Discriminating photographers can choose among four types of perspective by means of which they can create illusions of depth within the plane of their pictures:

Academic rectilinear perspective is characterized by the following qualities: Lines that are straight in reality also appear straight in the picture. Vertical lines must be rendered vertical and parallel in the transparency or print regardless of the direction of the view. All other lines are rendered in the form in which they appear to the eye.

Unless the photograph is taken with the camera held level, achieving this form of perspective requires either the use of a view camera equipped with swings, or that the distorted negative, taken

with a nonswinging camera, be corrected during enlarging. Tilting the paper will make vertical lines that converged in the negative because of perspective appear as verticals in the print. This form of perspective is normally preferred in architectural and commercial product photography. In comparison with other forms of perspective, it creates the most formal and static impression.

"True" rectilinear perspective is identical to academic rectilinear perspective except for one characteristic: Vertical lines will be rendered vertical in the transparency or print *only* if the picture was made with the camera held level; if the camera was tilted up or down, vertical lines will appear to converge in the picture, and this convergence, this tilting of vertical lines, far from being considered a fault, is now accepted as normal—the perfectly natural manifestation of extension in the vertical direction, that is, perspective, the graphic symbol of height.

This form of perspective can be produced with any camera equipped with a lens capable of rendering straight lines straight and is used in the overwhelming majority of photographs. In comparison with academic rectilinear perspective, it creates more informal, lively, and dynamic impressions.

Cylindrical perspective is produced by all cameras whose lenses describe an arc during the exposure—the so-called panoramic cameras. It is characterized by the fact that straight lines are rendered in the form of curves. The degree of curving depends on the distance that the line is from the long sides of the picture: The closer it is, the more strongly curved. This applies to all straight lines except those running perpendicular to the plane of the swing of the lens; these are rendered straight.

This more or less pronounced curving of actually straight lines is the price a photographer must pay for the unusually large angle of view covered by this form of rendition, which, in most cases, encompasses 140 degrees. This is approximately three times the width of the angle covered by a standard lens. Actually, of course, this curving of straight lines is *not* a form of distortion, but a perfectly natural manifestation of perspective. This is easily proven by performing the following experiment:

Place yourself centrally in front of a very long building, and take three different shots with any nonswinging camera. Of these, the first should be head-on, the second with the camera pointed toward the left

50

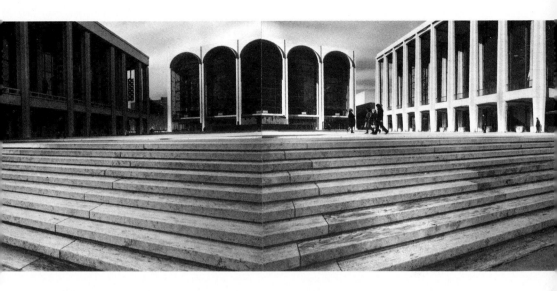

The development of a cylindrical perspective. *Above:* Composite view consisting of two photographs taken from the same position with an ordinary camera, one shot toward the left, the other toward the right. Notice the unnatural break in the actually straight steps in the center of the picture.

Below: The same subject including the same angle of view photographed with a panoramic camera. This time, however, there is no unnatural break in the center of the picture—the curving of the steps corresponds to the impression we would receive if we looked at the scene first toward the left, then, slowly turning our head, toward the right.

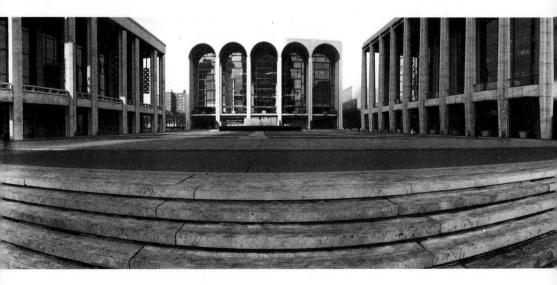

to include the left end of the building, and the third with the camera pointed toward the right to include the right end of the building. Process the film and join the three prints to form a panorama. Such a composite view would include the entire length of the building, something which would have been impossible to achieve even with a wide-angle lens, but where the individual pictures meet, there is a break in the horizontal lines of the building. However, the convergence of the horizontal parallel lines of the building toward vanishing points at the left and the right appears completely normal—just what we would expect to see in reality if we were to look, for example, along the length of a street, first in one direction, then in the other.

Now, a panoramic camera permits us to re-create the same impression, but, thanks to cylindrical perspective, in an improved form: A picture made with a panoramic camera would include the same enormous angle of view as our three-part composite, but instead of the two unnatural and ugly breaks in the straight lines, we would get a gentle curving—exactly what we would see if we were to contemplate the long building by looking first at its left end, then letting our eyes travel slowly toward its center directly in front of us, and from there on toward the righthand end. Then, we would also see that the apparent height of the building is greater in the center than at both ends where it is diminished due to the effects of perspective. And if we would mentally reconstruct this view by drawing the roof and base lines of the building, connecting both ends with the middle in order to avoid any unrealistic breaks, we would have to draw these actually straight and horizontal lines as curves.

Panoramic cameras already existed more than half a century ago but cylindrical perspective is still regarded by many people as a distortion. Actually, it is considerably truer to reality than the generally acclaimed, academic rectilinear perspective, which violates the indisputable optical law that receding parallel lines, *no matter in which direction they run,* must appear to converge toward a common vanishing point. Used and regarded in this sense, cylindrical perspective becomes a means for extending our visual experience by showing us reality as it really is—*not* as we think it should be.

Spherical perspective is similar to cylindrical perspective, only "more so." Instead of rendering straight lines curved in only one direction, it curves them in two, the sole exception being straight lines that appear as radii in the picture; these are rendered straight.

In its most extreme form, spherical perspective enables a photographer to cover an angle of view encompassing about 180

degrees. How fantastically large such an angle is becomes clear only if one realizes that it includes one-half of everything a person can see if he looks in *every* direction: front, back, right and left, up and down, including the sky above and the ground below. Not surprisingly, such a spherical view appears rather unorthodox when compared with more conventional forms of perspective. But, like cylindrical perspective, it is *not* a form of distortion, but a scientifically accurate way of rendering three-dimensional reality in picture form. Actually, it is our way of seeing that distorts reality. The fish-eye lens and its spherical perspective show us how it really is, although the viewer may have to learn how to interpret such photographs correctly. This is most easily accomplished by studying fish-eye photographs one small section at a time: Hold the picture vertically in front of you, and look only at its lower part; then continue looking at this area while slowly rotating the print. In this way, the apparent distortion is minimized, and what is actually a single view can now be read as if it were a series of pie-shaped pictures. Later, when this extreme form of spatial rendition has become more familiar to the viewer, it will be possible for him to examine an entire fish-eye photograph at once—and comprehend it.

Filtration

In color as well as in black-and-white photography, filters are indispensable for creative control. Ambitious photographers who wish to improve the quality of their work have the choice of the following possibilities:

In color photography, filtration takes three forms:

1. *Color conversion filters* enable a photographer to use daylight color film in artificial light, and vice versa. This is a great convenience for anyone who works with a camera that does not accept interchangeable film magazines or film holders, since it permits him to make outdoor and indoor shots on the same roll of film.

2. *Light balancing filters* enable a photographer to use a specific type of color film in conjunction with a type of light for which it is not balanced. For example, if daylight color film that is balanced for standard daylight were to be used in conjunction with yellowish early morning or reddish sunset light, the resulting transparencies would have a more or less pronounced yellow or red color cast. Use of the appropriate light balancing filter prevents this.

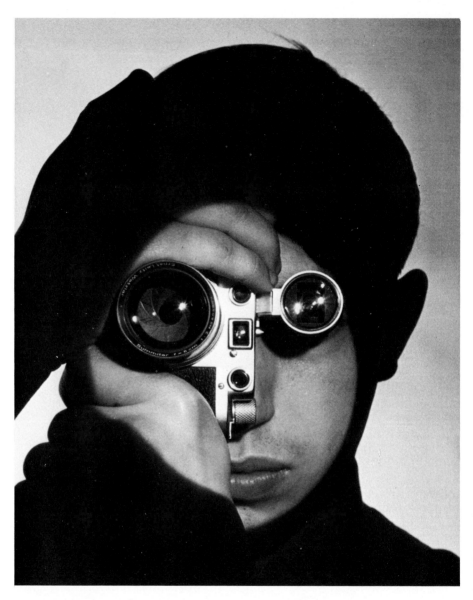

The photo-journalist, by *Andreas Feininger.* An almost surrealistic photograph originally made for use on the cover of *Life.* Theoretically, the concept of a photo-journalist can be reduced to three essentials: the brain, the viewfinder, and the lens. These are combined here in graphic-symbolic form in the simplest possible way to produce what I consider one of my most successful photographs.

3. *Color compensating filters* enable a photographer to give his transparencies an overall tone that is different from what they would have had if no filter had been used. For example, to indicate specific moods, a photographer may wish to change the overall tone of his slide toward pink, or blue, or mauve. Similarly, when making a color print, he may wish to increase, decrease, or completely change the overall shade inherent in the color negative. Use of the appropriate color compensating filter enables him to do just this.

Explicit instructions regarding the use of filters in color photography can be found in the author's books, *The Complete Colour Photographer* (Thames and Hudson, 1969) and *Basic Colour Photography* (Thames and Hudson, 1972).

In black-and-white photography, filtration takes two forms:

1. *Correction filters* enable a photographer to change the response of panchromatic film to color so that *all* colors are transformed into gray shades of corresponding brightness values. Without such filters, green, for example, might be rendered somewhat darker than it appears to the eye, and red somewhat lighter.

2. *Contrast filters* enable a photographer to change the response of a film to specific groups of colors, for example, the reds or the blues, in such a way that these colors appear in the print as shades of gray that are lighter or darker than they would have appeared if no filter had been used. This provides the photographer with an invaluable means for distinguishing in his black-and-white photographs colors of different hue but similar brightness, which otherwise would be rendered as identical shades of gray. This might enable a photographer to avoid undesirable merging of subject and background, for example.

Explicit instructions regarding the use of color filters in black-and-white photography are given in the author's book, *The Complete Photographer* (Thames and Hudson, 1965).

Lighter or darker

Not only in black-and-white photography but also in color, a photographer has the choice of pictures in different degrees of lightness. This choice is important because the overall tone of a photograph influences its mood. A light tone is suggestive of youth,

happiness, and pleasurable feelings, and puts the viewer of the picture in a gayer mood than a dark overall tone, which creates a more serious, somber, and even ominous impression. Such differences in lightness are easily produced by adjusting the print exposure time accordingly.

In color photography, differences in exposure produce differences in the color saturation of the transparency. A short exposure yields a transparency in which subject color is darker, richer, and more saturated than in a transparency that received a longer exposure, producing a more diluted, pastel effect. In this connection, the terms "short" and "long" imply, of course, only relatively small deviations from normal exposure in accordance with the data established with the aid of an exposure meter. Even slight variations suffice to yield quite different results.

Contrast high or low

In black-and-white but *not* in color photography, a photographer has the choice of rendering his subject in a more or less contrasty form. (*Contrast* here implies the degree of difference between the lightest and darkest shades of the picture.) In a high-contrast rendition, tonal values run the gamut from black to white; in a low-contrast rendition, they range either from black to gray, from gray to white, or from dark gray to light gray, but pure black and pure white do not occur together in the same picture.

Like overall tone, contrast influences the mood of a photograph and becomes a valuable means of graphic control. The photographer may choose between a softer (low-contrast) or harder (high-contrast) impression. The techniques by means of which this can be accomplished are described in my book, *Manual of Advanced Photography* (Thames and Hudson, 1970).

Sharpness or unsharpness

It may seem axiomatic that any good photograph should be sharp, because this is the way we see reality. In my opinion, this is a fallacy, for two reasons: first, because there is a world of difference between reality and a photograph (understanding the nature of this difference is so important a prerequisite for making good photographs that it will be the subject of a later chapter); and second, because we see sharply only that small part of reality on which our eyes and attention are focused, while the rest seems more or less blurred. Experienced photographers know this. They also know that they have the choice of different forms

of sharpness and blur in an unlimited number of degrees, each creating a slightly different impression. Here is a brief review:

Sharpness. Distinguish between two forms: overall and partial sharpness.

Overall sharpness exists if every part of the photograph is equally sharp. This makes for great clarity of rendition but also gives an impression of flatness. The picture will seem to lack depth. The cause of this phenomenon is, of course, the fact that in reality our eyes focus on only *one* section located in *one* specific plane of focus. As a result, a photograph that is sharp in its entirety appears unnatural. (Since nearby objects are rendered as sharply as distant ones, both seem to be located in the same plane—the plane of focus of the eye—something which, according to our experience, is incongruous.) However, considerations of clarity of rendition often override this aspect, particularly in objective photography (p. 22). Overall sharpness is the combined result of correct focusing, relatively small diaphragm aperture, high shutter speed, and fine-grain film or development.

Partial sharpness. The part of the picture comprising the subject proper is rendered sharply, while everything else is more or less blurred. This form of rendition corresponds most closely to the way we see things in reality. The technique used to achieve this effect is called "selective focus": The lens is focused on the particular plane in depth that must be rendered sharply, while the diaphragm is stopped down only moderately or not at all, letting the rest of the image trail off into unsharpness. This form of limited sharpness is especially suited to creating illusions of three-dimensionality and depth in the picture; to emphasizing a subject of limited extension (for example, a face or head, in contrast to a landscape, which in this sense is unlimited); and, in subjective photography, to creating specific moods.

Unsharpness. Distinguish among three different forms of photographic unsharpness:

Overall unsharpness. The entire picture is unsharp. Although normally a fault to be avoided, overall unsharpness can occasionally be used as a means to express in graphic form intangible subject qualities like femininity, tenderness, love, and confusion, or to create a dreamlike, unrealistic atmosphere of fantasy.

Overall unsharpness can be achieved in several ways: with the aid of special soft-focus lenses; by throwing the image more or less out of

focus; and with the aid of a diffuser. A fourth possibility, throwing the image out of focus while enlarging a sharp negative, has the advantage that the negative can also be made to yield a sharp print in case the unsharp version turns out unsatisfactory; on the other hand, the dark areas will bleed into light ones in the print, whereas if the negative itself is unsharp, light areas bleed into dark ones, an effect that is more in accordance with the radiant nature of light.

Directional blur due to subject movement is the most effective graphic symbol of motion. The higher the degree of blur, the stronger the feeling of speed. The precise degree of blur is a function of shutter speed relative to the speed of the motion. The slower the shutter speeds, the more pronounced the blur will be. For best results, the camera must be held perfectly still during the exposure, because it is the contrast between sharpness and blur that creates the impression of speed: the blur of the moving subject against the sharpness of the stationary background. Needless to say, varying the shutter speed and thereby varying the degree of blur can create any impression from very slow to very rapid motion.

Directional blur due to camera motion is another effective means of symbolizing motion. In this case, the camera is aimed at the moving subject and panned on target while the photographer releases the shutter during the swing. The moving subject will be rendered sharp, while the background will be blurred. In comparison to the previous method of symbolizing motion, this one has the advantage of yielding a sharp and well-defined picture of the moving subject, while the normally less important background is rendered blurred.

Picture proportions

Although all negatives shot with the same camera have the same proportions (unless the camera accepts interchangeable film magazines of different formats), this does not mean that all prints have to have the same proportions. As a matter of fact, cropping during enlarging is an important aspect of composition, besides being a good way to avoid monotony. A photographer has the choice of an unlimited number of different proportions ranging from extremely narrow horizontal pictures to square ones to very narrow vertical prints. I know that some photographers, among them Edward Weston and Henri Cartier-Bresson, refuse to crop their pictures; the only concession they make to variety is that they choose between a horizontal and a vertical format. I

don't see any justification for restricting oneself to the arbitrary choice of two formats, or if the negatives are square, no choice at all. This I gladly leave to the filmmakers who, in this matter, have no choice. But as a still photographer who has a choice, I want to be free to utilize every available means for making my pictures more effective, more expressive, and more graphically powerful, and choosing the most appropriate print proportions is one of them.

Summing up and conclusion

Give twenty photographers the same kind of equipment and tell them to photograph the same subject, and they will come back with twenty different pictures. And of these twenty pictures a few will probably be bad, many conventional, some good, and one or two—perhaps—outstanding. Why? Because of the way each photographer made use of his privilege of choice, in regard to technique as well as subject approach and rendition.

I have said repeatedly that every subject can be photographed in any number of different ways. In other words, every picture is the combined result of innumerable decisions made by the photographer: a little bit closer . . . a little bit more from this side, toward the left, from above . . . the light is not quite right yet, and clouds are dull, I'd like a bit of haze, perhaps I better try again tomorrow . . . those colors don't go together at all, let's try a purple scarf instead . . . I think a lens of longer focal length would give me a better perspective . . . up with the chin, no, that's too much, OK, that's just right . . . now, which color filter would be best for separation in black-and-white of subject and background? . . . the light looks awfully blue to me, let's warm it up a bit with an 05Y filter . . . no, better use a 10Y . . . the background is still too dark, let's have a little bit more light . . . watch out for those ugly shadows! . . . and so on and so forth. . . .

Any photographer knows, for example, that the correctly adjusted dials of a light meter will give him the choice of about two dozen different exposure settings, each of which would yield a technically perfect negative or color transparency. Now, the average photographer probably would automatically choose the combination that allows him to make the shot without the danger of accidental camera movement blurring the picture, say, 1/250 sec. at $f/8$, without giving further thought to what this might involve in terms of motion-stopping power and depth of field. In contrast, an experienced photographer would

instinctively ask himself: How much depth do I want to cover sharply? Is there subject motion involved, and how do I want to handle it? Freeze it? Indicate it in the form of blur? How much or how little blur? And not before he has answered these questions to his own satisfaction would he decide which one of all the possible combinations of diaphragm stop and shutter speed to use. Because he knows that

know-how is worthless unless guided by know-why.

The scope of photography is limitless or, to be realistic, as wide as the interest, curiosity, imagination, and phototechnical know-how of the photographer. This is true in two respects: in regard to the *variety* of subject matter, and in regard to subject *rendition*. Where some photographers see very little, others discover entire worlds. This, then, is what counts. It is the secret of making good photographs: *not* whether you use a Nikon or a budget SLR, *but* whether you use the right or wrong *type* of camera; *not* whether you photograph a famous movie star or little Jane Doe, *but* what you see in the subject of your photograph and are able to reflect in your picture; *not* whether you get sent to Tashkent or photograph the Taj Mahal, *but* the way in which you approach the portrait of a town, a street, or a building. In other words, what counts is the depth of your involvement, the way you identify, your reaction to what you see and feel in the presence of your subject, and the degree of competence with which you are able to express your intent in your pictures.

What matters is *not* what you photograph, but how you photograph it.

IV. The Characteristics of Photography

Like any other form of communication, photography is based on symbols. What makes it different from any other form of communication is the fact that these symbols are universal: They can be understood by anyone anywhere in the world. Seeing the photograph of a child, for example, anybody can understand the meaning of the picture, no matter what his language or alphabet.

This universality seems to me one of the most important characteristics of the photographic medium. Its ramifications touch on fundamental concepts like *responsibility, immediacy,* and *symbolism—* concepts that photographers don't usually associate with their craft. Perhaps this is one of the reasons why so many photographs are so mediocre.

RESPONSIBILITY

The fact that his statements can be read by anyone anywhere in the world should, it seems to me, make a photographer think twice before he takes a picture. Specifically, he should ask himself three questions:

Is what I want my photograph to say worth saying?
Do I express myself clearly enough to be understood?
Does the photograph honestly express my convictions?

Sense and nonsense. People expressing themselves in speech or writing are generally rather careful to avoid saying anything that might stamp them fools. Not so photographers, if one is to judge by the flood of trite and boring pictures published year in and year out in photographic magazines and annuals and shown at exhibitions. Using an analogy with speech, most of these pictures are as hackneyed as

saying that a rose is a rose is a rose; they repeat what has already been said a thousand times before; they say badly what others have said better; or they say nothing at all, in which case they are visual gibberish, meaningless statements toward which a viewer's reaction can only be, So what?

Most photographs are so easily made that the temptation to shoot first and ask questions afterwards is almost irresistible. Often, of course, this is the only way to avoid missing a unique opportunity for making a valid picture. However, it does not oblige the photographer to show the picture when he discovers afterwards that it is not as great as he had hoped; in that case, he should destroy it. As a matter of fact, showing only their best efforts and hiding or discarding the rest is the secret of many a successful photographer. In other words, discrimination and self-criticism are important prerequisites for making it in photography. If these two qualities can be exercised before a photographer releases the shutter, all the better.

Clarity of expression. The how of photography is just as important as the why, the meaning of the picture. What good is it if a photographer is compassionate, sensitive to feelings, aware of moods, gifted artistically, and privileged to witness great events if he is incapable of expressing his experience in picture form? In other words, the best intentions and opportunities are wasted unless the photographer is able to translate his visions into images on film. This, too, is part of the responsibility that a photographer, like any writer or journalist, has toward his public: He must be able to express himself in a form that his audience can understand.

One of the prerequisites for clarity of expression is, of course, familiarity on the part of the photographer with the means and techniques of photography. However, equally important is understanding the symbols of the medium, which are the conceptual building blocks of the picture. For, as cannot be said often enough, any subject can be seen and photographed in innumerable different ways, all technically perfect; yet some will be more effective than others because they were better conceived. In other words, phototechnical excellence in itself means nothing: A technically perfect photograph can be the world's most boring picture. Because, as I said in the beginning and want to repeat here for emphasis,

a good photograph is a successful synthesis of technique and art.

62

Honesty of expression. I firmly believe that an indispensable ingredient for the making of good photographs is the photographer's conviction that what he does is right and his own. Unfortunately, there seem to be as many phonies in photography as in other professions—people who imitate the work of others to hide their own lack of ideas, or who photograph slavishly the kind of subject that happens to be fashionable at the time. Remember when pictures had to be shot by available light? Or the craze of zooming in still photography? Or the wave of fish-eye views?. Needless to say, such photographers fool nobody but themselves. Unless they change their ways and do original work, they'll never make a worthwhile picture. I'll have more to say on this subject later (p. 135).

Another form of dishonesty in photography is perpetrated by those who, sometimes unconsciously, let their prejudices influence their work. This seems to be particularly common in politically motivated photoreporting. For example, the picture of a man seeking public office, if shot at an embarrassing moment or reflecting an awkward pose, can seriously affect his political career. Any photographer can accidentally make such an unfortunate shot, but only an unscrupulous one will exploit it. Similarly, a photojournalist sent out by his editor to report on a foreign country, by the way he slants his story—by what he does and does not photograph—can produce a misleading and dishonest impression. Exposing the deficiencies of a political system one dislikes is one thing; suppressing its positive sides is another. An honest photographer pays equal attention to both, aware of his responsibility as a reporter, because reporting means gathering the news without favor or prejudice, so that those for whom the report is intended can form their own opinions. To do this they need facts, not photographic fiction.

And finally, there are those photographers who resort to posing their subjects and faking. Posing, at least, is honest insofar as an obviously posed photograph is recognizable for what it is. But a photograph that pretends to be unposed and is not is a fake, a photographic lie. Examples of the first category are all those photographs of the nude in which young women are shown in contrived positions looking ridiculous or absurd because normal girls would never comport themselves like this. Why anyone would want to make or look at such pictures is beyond me. They do not even have sex appeal. And typical examples of faking are, among others, photographs of dead insects passed off as live and outdoor scenes shot in the studio. Needless to say, this kind of photography can never be good.

IMMEDIACY

Next to universality, immediacy is the most unusual characteristic of the picture language of photography. Consider the following:

The spoken or written word is often ambiguous, meaning one thing to one person, another thing to another, and something else to a third. Take, for example, the word *art*. It has one meaning to a serious painter or sculptor, another to the art director of an advertising agency or his client, and a third to the housewife who maintains that cooking is an art. Or think of the description of a character in a novel. Then compare your mental image with the appearance of the actor or actress who plays this role in the movie adaptation of the book. Rarely, if ever, will your concept of the person in the book coincide with the way the director of the movie depicted this man or woman in the film version, because both images were based on a verbal description, open to interpretation. In contrast, a photograph of this character would have been unequivocal, complete, and final, leaving little doubt about this person's real identity. Obviously, in comparison with words, pictures, because of their immediacy, are less ambiguous in their meaning, more reliable, more precise.

Not only does the great immediacy of pictures manifest itself in the fact that pictures are more easily understood than words; it also has a stronger impact on the viewer than a verbal account. How often do we read about some disaster, only to dismiss the whole story in short order? But then we see photographs of the event and our reaction changes. Somehow the catastrophe appears more real.

Unlike words, photographs are tangible, they are evidence, they are real. A writer or journalist may say anything he wants, distort the facts, fabricate his story, or might not even have been there. But a photograph is irrefutable proof of something that happened in front of the camera at the moment the picture was made. No matter how strange the subject may appear, how distorted, how hard to believe, it must have been there, because nobody can fabricate pictures. This, of course, does not mean that photographs cannot be made to lie, either intentionally by an unscrupulous photographer, or unintentionally by an incompetent one. I already mentioned the first possibility, citing as examples faking and politically influenced, dishonest reporting. Other instances are common in advertising, where shoddy products are made to look substantial by means of dishonest photography, small ones big, and dull ones glamorous.

(Text continued on p. 73)

Weather balloon, by *John Veltri.* The most powerful color effects are always achieved through juxtaposition of two complementary, fully saturated colors, here, yellow and blue. Note, how the yellow graduates into red, a color which is "harmonious" to yellow and blue (i.e., the three colors form an equilateral triangle on the Munsell Color Wheel, producing a "color accord"). Silhouetting black adds strength to the color composition, making this picture a "perfect photograph."

Above: **Wild bee on a dandelion flower;** *opposite:* **Red-eyed horse fly,** both by *Andreas Feininger.* Pictorially, the common denominator of both subjects is that, photographed in black-and-white, they would have been totally ineffective: if color is a subject's most outstanding quality, only a rendition in color can produce a "perfect photograph." More about this on pp. 84-85.

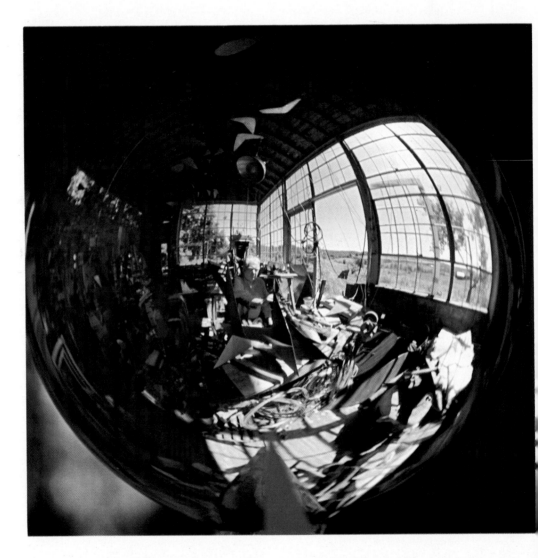

Above: **Alexander Calder in his studio;** *opposite:* **Jupiter rocket and the moon,** both by *Andreas Feininger.* To capture the fascinating atmosphere of this famous sculptor's overcrowded studio, I would have liked to make the shot with a fish-eye lens; but lacking one, I photographed it instead reflected in a mirrored sphere which produces the same effect. And to render the moon in a size sufficiently large for my purpose, I had to use an extreme telephoto lens with a focal length of 40 inches in conjunction with 2¹/₄″ × 2¹/₄″ film. This made these particular cases unusual insofar as each required an unusual subject approach—the only way for me to get what I consider a "perfect photograph."

Two photographs of divers by *John Veltri* prove that it is not the number of different colors—the quantitative approach—but the way in which color is used—the qualitative approach—which makes for "perfect photographs." Although both pictures are virtually monochromes, they would have been ordinary if rendered in black-and-white whereas, in color, they are outstanding.

Old graveyard under a full moon, by *Andreas Feininger*. Rendered in shades of black-and-white, this scene could still have been effective. But the fantastic color of the light—a mixture of red and pink and mauve reflected from the western sky where the sun had already set but the clouds were still aglow—prompted me to make the shot in color, a spur-of-the-moment decision which I have never regretted. In my opinion, it turned what otherwise might have been a "good picture" into a "perfect photograph."

Unintentional camera lies are often innocently perpetrated even by honest photographers. Every photograph that didn't come off, that disappointed its maker, that failed to convey the spirit of the subject to the viewer, is a camera lie insofar as it did not truthfully depict the subject. For example, most photographs of heroic landscapes disappoint because the landscape has lost its grandeur in the picture. Similarly, in most photographs, California's towering redwoods and sequoias seem reduced to the size of ordinary trees, their overwhelming magnificence gone. What happened?

What happened was that the photographer failed to give his picture scale—to include in the composition a familiar object of known dimensions, so that the viewer could gauge the size of the main subject. For example, a human figure in the distance, rendered small, diminished by perspective, would make the landscape or trees appear huge.

Consider photographs of an automobile race. The essence of such an event is action, drama, competition, speed. But most photographs of automobile races are taken with very high shutter speeds. As a result, the cars are rendered sharply. Unfortunately, in picture form, there is absolutely no difference between the sharp images of automobiles racing and automobiles standing still. The feeling of speed is missing in this kind of technically perfect sharp photograph, which, by making the competing cars appear to stand still, lies to the viewer of the picture. To express the sensation of speed photographically, movement must be indicated in symbolic form by blur, with either a shutter speed too slow to freeze the motion or the pan (p. 58).

Another familiar example of an unintentional camera lie is the outdoor portrait taken in bright sunlight in which shadows appear too black, lines harsh and exaggerated, and features distorted because the model couldn't help but squint. No wonder such portraits look unnatural. Much better pictures could have been made either in the open shade, or under a slightly overcast sky. In either case, daylight would have been diffuse, shadows soft and transparent, and the illumination easy on the eyes of the model, who could have relaxed and assumed a natural expression.

Another unintentional camera lie often seen is the candid shot of people in the street taken with a wide-angle lens, a popular practice because "wide-angle lenses have greater depth of field." This example

involves a double lie: unavoidable perspective distortion that makes the people appear unnatural by giving them abnormally large heads or hands; and, for all practical purposes, depth of field is no greater than that of lenses of standard focal length or even of telephoto lenses, because what the photographer gains in terms of depth of field he loses in image size. Equality of f/stop and scale of rendition provided, all lenses regardless of focal length deliver identical zones of sharpness in depth.

Yet another photographic deception is that black-and-white photographs of colorful objects render colors of different hue but equal brightness in equal shades of gray. Although this represents a technically correct form of color translation into shades of gray, the effect is always unsatisfactory, because the vivid color contrast apparent to the eye in reality, for example, between red and blue, is not reflected in the gray-toned image. Elements of the subject that, due to differences in color, appeared separated in reality will merge in the picture. To avoid this fault and produce more natural-appearing impressions, colors of different hue but equal brightness must be translated into different shades of gray by means of filtration (p. 53).

A common form of photographic lie is found in photographs of buildings taken with the camera not held level, where vertical lines are rendered converging. Unless the concept of height is intended to be expressed in symbolic form, such converging verticals appear unnatural. Therefore, to avoid an unintentional camera lie—the impression of leaning walls and buildings on the verge of collapse—verticals must be rendered parallel, either with the aid of the swings of a view camera, or by correcting the distorted negative during enlarging as explained in my book *Darkroom Techniques,* Vol. II.

Normally, no difference exists between the photographic rendition of reflected and of radiant light: The image of a sheet of white paper appears just as bright and white as the image of the sun. Therefore, to express the difference in brightness between direct (radiant) light and mere white (reflected) light, the concept of radiance has to be indicated in symbolic form in the picture by, for example, lens flare, diaphragm stars, or halation. Although normally considered faults, these manifestations of radiant light, imaginatively used, become means by which photographers can indicate degrees of whiteness and thereby render their subjects more truthfully.

Conclusion

To make the most of the unique characteristic of immediacy inherent in any photograph, a photographer must analyze the essential qualities of his subject, then emphasize these qualities graphically by using the appropriate means of rendition: filtration to separate colors, blur to denote motion, halation to indicate the radiance of direct light, and so on. In other words, merely pointing the camera at a subject and exposing the film correctly is not enough to produce good photographs. To avoid unintentional camera lies, the right kind of photographic symbol must be used. What this implies is explained in the following chapter.

SYMBOLISM

Perhaps the greatest obstacle to the making of good photographs is belief in the old saw, "The camera does not lie." It seems to imply that a photograph, being the product of a machine, must *ipso facto* be a truthful reproduction of the subject it depicts, no matter whether the picture appears satisfactory or inadequate. For what can be more accurate and realistic than a picture made by a machine?

The danger inherent in this attitude toward photography lies in the fact that it makes people stoically accept their inadequate photographs, for how can you argue with a machine? Or with the laws of optics? Or with a densitometer?

I strongly disagree. As a matter of fact, in my opinion, precisely the opposite is true: *every* photograph, with the possible exception of the picture of a page of print, is basically a lie, for these reasons:

Reality is three-dimensional, but a photograph has only two dimensions—depth is missing.

Reality is colorful, but a black-and-white photograph consists only of shades of gray—color is missing.

Two vitally important aspects of reality are motion and life, but a photograph is a still—movement and life are missing.

Now, the first requirement of any truthful representation is that it faithfully reflect all the important qualities of the original. But what

are the most important qualities of reality, the original that a photograph is supposed to copy? Obviously, they are three-dimensionality and depth, color, motion, and life—precisely the qualities that cannot be rendered directly in photographic form.

On the other hand, it is also undeniable that anybody recognizes, say, a house or a person in a photograph, despite the absence of depth, color, motion, and life. How can these two apparently opposite views be reconciled?

The answer to this paradox lies in the fact that photography is built on symbols. Since this concept is probably unfamiliar to many readers, let me clarify it by means of an analogy with speech and writing, forms of communication that also are based on symbols.

Whenever we want to communicate with another person, we use words. A word is a combination of different sounds, each of which is represented by a letter or group of letters. Words are symbols of specific concepts, objects, qualities, and so on. Anybody who speaks English is familiar with the graphic symbols *G-I-R-L*, instantly translates them into the concept for which they stand, and forms in his mind the image of a girl. This translation from letter to sound to word to concept to mental image is such an automatic process that nobody is consciously aware of it. But without these auditory and graphic symbols we wouldn't be able to communicate.

A similar situation exists in photography. Here, too, symbols are the indispensable means that enable us to express in photographic form qualities that cannot be expressed directly, such as depth, color (in black-and-white photography), motion (in still photography), and life. Here are some examples:

Depth

Depth can be symbolized in a photograph, i.e., the illusion of depth can be created, by means of the apparent converging of actually parallel lines. The more abrupt the degree of convergence, the stronger the illusion of depth. Another symbol of depth is diminution, the apparent decrease in object size with increasing distance from the observer. A figure rendered small in the picture seems to be farther away than one rendered larger. A third symbol of depth is overlapping. An object that overlaps another one in the picture is obviously closer to the camera, implying depth. A fourth indication of depth is

76

foreshortening. Strictly speaking, this is only another form of diminution. If an object that we know from experience to be round is rendered in the form of an ellipse, that is, foreshortened, we know, also from experience, that it must have been photographed at an angle. The presence of perspective implies depth. Still another symbol of depth in photography is contrast between sharp and unsharp. If a subject is shown sharply against unsharp picture elements, we know— again from experience, because this is analogous to the way we see— that the unsharp elements are behind the subject, are background matter, are farther away. Finally, depth can be symbolized by means of aerial perspective. The subject appears increasingly lighter the farther away it is, a natural consequence of the effect of atmospheric haze.

Color

In black-and-white photography, color is symbolized by brightness contrast—differences in the brightness of gray shades. In this respect, aggressive, hot colors like red and yellow are normally represented by lighter tones than passive, cool colors such as blue and green, which normally make a darker impression and should be represented by darker shades of gray. The means for controlling the translation of colors into shades of gray are the color filters.

Motion

In a still photograph, motion can be symbolized by means of blur— blur, in this context, meaning directional unsharpness, unsharpness in only one direction, the direction in which the subject moved. Practically, this can be accomplished in two ways (pp. 56–58): through appropriate choice of shutter speed; and through the technique of panning. Motion can furthermore be symbolized indirectly through appropriate composition and by other means. Altogether, nine different symbols of motion are at the disposal of any photographer who wishes to avail himself of them; they are discussed in the author's book, *Manual of Advanced Photography* (Thames and Hudson, 1970).

Radiant light

A source of radiant light, which ordinarily would appear in a photograph in the same form as reflected light, that is, as white, can be symbolized by means of halation, flare, stars produced by the diaphragm, or special screens. These techniques are also explained in *Total Picture Control.*

CONTROL IN PHOTOGRAPHY

Two things should be obvious from the foregoing:

1. Photography is *not* the simple naturalistic medium of reproduction most people believe it to be.

2. Any subject can be rendered in many different forms, some of which must obviously be better than others.

The consequences of this realization are enormous and contain the key to good photography. Photography is either very simple or very complex, depending on the photographer's attitude and demands. Nothing is easier than taking a snapshot and producing a recognizable picture of a subject. However, there is a world of difference in effectiveness between a recognizable subject and a good picture. Few things demand as much knowledge, insight, and artistry as making good photographs, the kind people remember.

To make the first kind of picture, all a photographer has to do is point the camera in the right direction, focus sharply, expose correctly, and let his photo store take care of the rest. Within a few days, he will receive a pretty picture. To be able to make the second kind of photograph, however, a photographer must first realize four principles:

1. Photography is *not* a naturalistic medium of rendition.
2. Naturalness in photography is based on illusions.
3. A naturalistic photograph is not necessarily a good picture.
4. Good photographs are the result of making the right choices.

Let me amplify these premises:

1. A reproduction that does not reproduce the original's most important qualities—depth, color, motion, and so on—is obviously not a true reflection of the original and can therefore not be called "naturalistic."

2. If a photograph appears natural, this appearance is based on illusions—the illusions of depth, color (in black-and-white photography), motion (in still photography), and so on. These subject qualities cannot be rendered directly in photographic form; but illusions of depth, color, motion, and so on can be created by means of photographic symbols.

3. A seemingly naturalistic photograph can very well be an unsatisfactory picture. This is borne out by any outdoor portrait shot on color film in the open shade or under trees in which the face appears blue or green, respectively. Although such a color cast is the perfectly natural consequence of the circumstances under which the picture was made, it is considered unnatural by most viewers, who expect a portrait to look as the subject would have appeared in colorless light.

Other instances in which photographs that conform to reality appear unnatural include pictures of buildings in which the vertical lines converge. Although this convergence is a perfectly natural manifestation of perspective in a vertical direction, this form of perspective is rejected by many people because they know that verticals are parallel. Or consider black-and-white photographs of colorful objects, in which colors of identical brightness but different hue are rendered in identical shades of gray. Although these gray shades represent the true brightness values of the colors, they seem unnatural because they fail to represent the color contrast which the eye saw in reality.

In all these cases (and there are many others), forms of rendition that conformed as closely as possible to reality were rejected as unnatural because of preconceived notions in the mind of the beholder. To me, this is proof that, in order to create a natural impression, a subject may have to be falsified in the reproduction. Specifically, in the cases mentioned here, the color portrait should have been filtered to remove unnatural-looking amounts of blue or green; the vertical lines should have been made parallel with the aid of view camera swings; and in black-and-white photography, red should be made to appear as a lighter shade of gray than blue by means of the appropriate color filter.

4. Since taking a snap and producing recognizable pictures are so easy, many photographers reason: Why should I worry about perspective, filtration, color transformation into black-and-white, rendition of motion, or which shutter speed or diaphragm stop to use? After all, my camera and film automatically take care of all these things. No matter what I do, buildings will always appear in perspective, my pictures will always have depth, colors will always appear on color film or be transformed into the gray-tone values of black-and-white; and as long as I center the needle of my camera's exposure meter in the slot, my films will be correctly exposed. So why should I give these matters a thought?

You should give them a thought, because any subject can be rendered in many different forms; because the first view of a subject is not necessarily the most effective one; because the symbols of photography are manifold, and some will yield better results in specific cases than others; because, as a creative photographer, you have a choice; and because, if you plan ahead, you will get *better pictures* than if you are satisfied to accept whatever chance provides.

Good photographers rely on choice, not chance.

The case for photographic control

Making a photograph means translating from reality into picture language. And as in translating from one language into another, this can be done in two different ways: literally or freely.

A literal translation is one that slavishly follows the original, heedless of the fact that what sounds good in one language may sound terrible, or may even be gibberish, if translated literally into another. As a result, in comparison with a free translation, a literal translation is usually clumsy and occasionally incomprehensible.

A free translation is one that follows the spirit rather than the letter of the original. As a result, the translator is able to preserve the character of the original in the translation and thereby convey the essence and meaning of the work.

In black-and-white photography, an unfiltered rendition of the colors red and blue would be equivalent to a literal translation, since these colors would be represented by gray shades of precisely corresponding brightness values. But for reasons already mentioned, such a translation would produce an unnatural impression. It would be clumsy, perhaps even visual gibberish, because the gray shades representing the two colors would be too similar, perhaps even identical, causing the picture elements to blend and making it difficult, if not impossible, to read the picture correctly. In contrast, a correctly filtered version could be compared to a free translation, because it would convey the spirit of the two colors in terms of black-and-white, thereby making a more truthful impression. Strictly speaking, it would be a form of photographic lie, albeit a positive one.

The same considerations apply, of course, in the case of the converging verticals mentioned earlier. Here, too, a literal translation

of reality into picture form, a rendition that slavishly follows the laws of perspective, by permitting the vertical lines to converge, might create a clumsy and even misleading impression. With some new skyscrapers having walls that slant, it is especially important to convey a correct impression. Only by means of a free translation, or photographic lie, by deliberately falsifying the natural manifestations of perspective, can a photographer make pictures that capture the essence of the original.

Similar reasoning applies in the cases of the racing cars, which in the literal translation appeared to be standing still, and of the brilliant light source, which, literally translated into picture form, is indistinguishable from ordinary reflected white light. In both cases, only a free translation can convey the essence of the subject. In the case of the racing cars, speed, the essence of racing, must be symbolized by blur, even though this blur does not represent reality, where the panning eye saw the speeding cars sharply. And radiance, the essence of brilliant light, must be symbolized by halation, star shapes, or flare, despite the fact that these phenomena are not real. If we see them at all, it is because of an imperfection in our vision.

Conclusion: Photographers who want to make good pictures have to make a choice on three levels:

1. They must choose between a literal and a free form of translating reality into picture language.

2. They must choose their photographic symbols correctly; for example, in the case of the racing cars, they must choose directional unsharpness over panning or freezing motion through use of very high shutter speed.

3. They must choose one of many possible degrees of the chosen symbol; for example, a specific shutter speed to produce a specific degree of blur that is not too little, nor too much.

A definition of photographic control

Purists in photography frown upon the concept of control, which they equate with faking. They point to the alleged fact that Edward Weston made only contact prints because he considered enlarging a violation of photographic integrity, and that Henri Cartier-Bresson never uses a color filter or crops a negative because this would be an

unwarranted interference with the immediateness of the picture. And what is good enough for their heros is good enough for them.

In my opinion, this kind of reasoning is not only fallacious, but self-defeating, because, instead of helping a photographer, it confines him. The fact is that there simply is no way a photographer can avoid using controls. Since the very nature of the medium forces him to use controls, he may as well select his controls according to the requirements of the occasion instead of meekly accepting whatever the occasion presents.

Whether or not he likes it, and regardless of whether he is aware of it, a photographer constantly uses controls when making pictures. Every time he focuses the lens, he chooses one specific plane in depth for sharp rendition instead of another one; every time he sets the diaphragm and shutter-speed controls of his camera, he chooses the specific extent of the sharply rendered zone in depth and the specific form for rendering motion; every time he uses a color filter to bring out the clouds in a black-and-white photograph he exerts control; every time he makes a vertical instead of a horizontal picture, he chooses between two possibilities. Every time he photographs his subject from a specific distance instead of going closer or staying farther away, every time he chooses a specific angle of view instead of another one, every time he uses a wide-angle or telephoto lens instead of a standard lens, the photographer makes a choice. HE USES CONTROL, no matter whether he does it unconsciously or with intent.

This, then, is the difference: You automatically get a recognizable picture no matter which lens you use, where you stand, or how you see your subject. But you get a good picture only if you do these things intentionally. And since you have to use controls anyway, you may as well select your controls on the basis of which will give you the best results.

The way I see it, a photographer using control does neither more nor less than any other craftsman or artist. Any automotive repairman has dozens of different wrenches, any painter dozens of brushes, any sculptor dozens of chisels, all slightly different, from which he chooses the one that will do the job best. A writer chooses from a number of synonyms the one word that, in his opinion, is most suitable in meaning, rhythm, and sound. A film director chooses from a number of actors the one most suitable to play a given role. And a photographer chooses from a number of different lenses, filters, shutter speeds, techniques the one that will give him the best result. That's all there is

to the concept of control. It simply means doing a specific job in the most efficient, workman-like way.

<div align="center">

**Using control in photography means
planning instead of gambling.**

</div>

The scope of photographic control

Photographers who realize the value of control and wish to make use of it in the interest of improving their work can influence the outcome of their pictures at three different stages:

<div align="center">

**Subject selection
Subject approach
Subject rendition**

</div>

Since I have already analyzed these points in my book *Manual of Advanced Photography* (Thames and Hudson, 1970) I can limit myself here to a brief review.

Subject selection

Although, in the majority of cases, the subject is given, there are occasions when a photographer has a choice. In such cases, his main concern should be with the presence or absence of *photogenic qualities;* these are discussed on pp. 151-153. Obviously, a photogenic subject will look more effective in picture form than an unphotogenic one.

Another point to be considered is suitability of the subject to the intended message of the picture. Any art director knows that different messages (and audiences) require different models—sophisticated or earthy, young or old, white or black, blonde or brunette, cold or sexy, and so on. Casting, therefore, often plays a decisive role in the success or failure of a photograph; it is an important aspect of control.

Still another aspect of subject selection became clear to me during work on my book *Trees* (Thames and Hudson, 1968). In an effort to help me, many people advised me about particularly beautiful trees that they had seen. But every time I took advantage of their kindness and went to look at the tree, I found that I had wasted my time. Sure enough, the tree was there, and it was beautiful, too. But from a photographer's point of view, it was useless. Either the background was hope-lessly cluttered, or nearby trees encroached on its silhouette, or telephone wires or power lines were in the way, or there simply was

not room enough for making a significant picture. All of which goes to show that, as far as a photographer is concerned, even the most beautiful subject can make a lousy picture. Experienced photographers know this and, rather than shooting unsuitable subjects, pass them by.

Subject approach

Confronted with a subject that promises to make a good picture, a photographer is faced with a number of choices in regard to the way in which he should approach it. Here are the most important ones:

Color or black-and-white. Consider two aspects: the purpose of the picture and the nature of the subject. Does the photographer intend to make the picture for his own enjoyment or for sale? In the first case, the nature of the subject will probably decide whether it should be shot in color or in black-and-white; in the second case, the decision depends on the intended use of the picture. The market for black-and-white photographs is much larger than that for color shots. But color commands much higher prices. Newspapers, except for their Sunday supplements, use mainly black-and-white pictures; calendar manufacturers prefer color shots; magazine and book publishers need both kinds. If slides for projection are required, as for lecturing or teaching, a 35mm camera must normally be used. For photomechanical reproduction in color, transparencies are usually preferred to paper prints. Transparencies in the sizes $2^{1}/_{4}'' \times 2^{1}/_{4}''$ and up are, as a rule, much easier to sell than 35mm transparencies, which some users of color photographs will not even consider. If color prints on paper are required, the photographer should work with negative color film. Although color paper prints can also be made from transparencies, this requires the use of an internegative and may involve loss of quality, besides being time-consuming and more expensive.

Experienced photographers know that some subjects turn out better if shot in color, others in black-and-white. In the first category belong all subjects whose most important characteristic is color, specifically food and fruit, flowers, paintings, certain types of women's wear, butterflies, sunset skies, colorful autumn foliage, and landscapes containing much greenery.

Typical black-and-white subjects are those characterized by graphically strong design, high contrast, deep shadows, backlighting, unimportance of or lack of color, and strongly pronounced surface texture. Furthermore, subjects that, to be effective, demand naturalness of color rendition, unless expertly photographed, generally look better

84

in black-and-white. A color portrait, for example, in which the face has reddish, bluish, or greenish overtones, will be rejected by most viewers, even if this color cast accurately reflects the light conditions at the moment of exposure; the same portrait in black-and-white would probably have been accepted—and this despite the fact that a black-and-white rendition by its very nature is less naturalistic than one in color.

When in doubt, some photographers make it a practice to shoot the subject both ways, once in color, and once in black-and-white. Although, technically, nothing could be simpler (provided you have two camera bodies or film magazines loaded with the respective types of film), the effect of such pictures is rarely satisfactory, because, normally, for best results, color film requires a low-contrast frontal illumination, while black-and-white renditions need relatively contrasty side- or backlight. Exceptions, of course, exist, such as the low-contrast, black-and-white Cape Cod landscape mentioned on p. 17.

Objective or subjective approach. The differences between these forms of subject approach have been explained on pp. 22–23. To some extent, an objective approach coincides with a literal translation and a subjective approach with a free translation of reality into picture-language. Which one of these two forms a photographer should choose depends on his personality and point of view, the purpose of the photograph, and the audience for which the picture is intended.

Other aspects of subject approach

Whereas making a decision in the two previous categories is relatively simple, making the right decisions in other aspects of subject approach can be a soul-searching experience. The possibilities from which to choose are virtually unlimited, and all the factors influencing the outcome of a picture are inextricably related—a change in one invariably affects all the others. The only way to make the right decisions is for a photographer to consider these factors one by one, always aware of the possibility that a later consideration may invalidate a prior choice, forcing him to start all over again. For example, the best direction from which to photograph a statue in a park may be obvious. But for a shot from this direction, the light may be unsuitable or the background bad. In that case, a photographer must either settle for another camera position, or come back at a different hour of the day when the sun is in a more favorable spot, or make the shot on an overcast day when the light is diffused and

highlights and shadows less obvious. A disturbing background can sometimes be subdued by means of selective focus (p. 57) or by waiting until it is in the shade, by which time, of course, the light on the statue may be unacceptable . . . and so on.

Another time, a conflict of interest may arise from the photographer's desire to extend the sharply rendered zone all the way from foreground to background while at the same time freezing traffic and passers-by. Unfortunately, the first objective necessitates a very small f/stop, which in turn requires a relatively long exposure time, while the second demand necessitates a very short exposure time, which in turn requires a relatively large f/stop. If, in addition, the light is not too bright or the film speed rather slow, our photographer is in real trouble and forced to compromise. Which aspects to favor and which to play down are decisions that can make or break his picture.

Specifically, the other aspects of subject approach demanding consideration include the following points, each of which influences the effect of the picture in a more or less decisive way:

1. *The incident light,* in regard to color, brightness, direction, degree of diffusion, and distribution of light and shadow.

2. *Distance between subject and camera,* from overall shot to close-up.

3. *Angle of view,* from very wide to very narrow.

4. *Direction of view*—front, side, back, top, and so on.

5. *Type of background,* evaluated in terms of lightness or darkness, color, design, possible interference and merging with the subject, presence or absence of undesirable subject matter, and so on.

6. *Type of foreground*—relevant, or empty and superfluous.

7. *Relationship of the various elements* of the subject or picture to one another, evaluated in terms of composition, perspective, overlapping, juxtaposition, foreshortening, distortion, and so on.

8. *Contrast,* whether within or beyond the capability of the respective film; possibility of halation and flare.

9. *Color* in terms of black-and-white rendition: color separation and contrast; in terms of color rendition: compatibility of the incident light with the respective type of color film, necessity for filtration, colors harmonious or clashing, warm or cold, and so on.

10. *Surface texture*—how to differentiate between sand, snow, stone, fabrics, wood, and so on; degree of sharpness; angle and direction of the incident light.

11. *Horizon,* higher or lower in the picture, emphasizing foreground or sky.

Subject rendition

Whereas subject selection and subject approach involve preliminary considerations, this phase of picturemaking is concerned with implementing the intentions of the photographer by physical means. Since these means have already been discussed in my book *Total Picture Control,* I can limit myself here to a summary of the factors involved. These are:

1. *The camera.* The choice is between different designs in different sizes; it makes an enormous difference whether a specific subject is photographed, say, with a 35mm single-lens reflex or a 4″ × 5″ swing-equipped view camera.
2. *The lens.* The lens must be of a suitable focal length, speed, covering power, sharpness, and angle of view.
3. *Filters.* For color photography, see p. 53; for black-and-white photography, see p. 55.
4. *Diaphragm aperture.* It affects the exposure and the depth of the sharply rendered zone.
5. *Shutter speed.* It affects the exposure and the degree of blur with which subjects in motion will be rendered.
6. *Perspective control,* by means of view camera swings or enlarger.
7. *Photolamps.* Select the lamp for emitting continuous or intermittent light (flash), and pay attention to its brightness, color temperature, and degree of diffusion.
8. *Film.* One may choose among different types of black-and-white and color films, with differences in negative size, speed, exposure latitude, contrast, and graininess, roll or sheet film.
9. *Film developer.* One may choose among normal, high-contrast, fine-grain developers, and more exotic ones.
10. *Sensitized paper.* Differences exist in contrast, surface, and print size.

Finally there are variations in the techniques of picturemaking that are not rigid, but subject to modification. Creative photographers will use the following controls to make their pictures more effective:

1. *Focusing,* in terms of sharpness, selective focus, and different degrees of unsharpness.
2. *Exposure,* in terms of color saturation in transparencies, depth of the sharply rendered zone, and manner of symbolizing motion, either by freezing or different forms and degrees of blur.

3. *Development,* in terms of contrast in black-and-white photography, speed increases, or pushing in color photography.

4. *Printing,* in terms of overall lightness or darkness, local contrast control (dodging), or variations in contrast gradient, perspective and distortion control, and print size.

Realizing how numerous and varied are the controls at his disposal, a photographer may at first feel overwhelmed, particularly in view of the fact that any one of these controls can be combined with any of the others. In practice, of course, this means that any subject can be photographed in an unlimited number of different ways, a fact that I have stressed repeatedly. With growing experience, however, this feeling of confusion will give way to a new, exhilarating sense of power—an awareness of creative potence, the feeling that almost anything is possible, and the reassuring realization that the effect of a photograph is *not* proportional to the cost of the equipment, but to the breadth of vision and the technical proficiency of the photographer.

TYPICALLY PHOTOGRAPHIC QUALITIES

To be able to make good photographs, a photographer must be familiar with the basic characteristics of his medium. This may sound utterly self-evident until one realizes that, because of the ease with which a recognizable photograph can be made, many photographers never give a serious thought to these basic qualities. After all, they say, things are going very well, thank you, photography is my hobby, and a hobby should be fun, not work, so why should I make further efforts?

A photographer should make further efforts because there is a difference between a recognizable picture and a good one. The first merely shows the viewer things as he has seen them before, and is therefore relatively uninteresting, having little value beyond that of an aid to memory. In contrast, the second shows him *more* than he thought he knew—a new slant on an old subject, a new point of view, a new idea, presented in a stimulating and graphically satisfying form. But to be able to produce the latter kind of photograph, a photographer must be familiar with basic concepts because the typically photographic qualities are of two kinds: those that tend to make a photograph good and others that tend to make it bad. To be able to take advantage

of the first kind and avoid the second, a photographer must be familiar with all of them.

Some of the typically photographic qualities discussed in the following pages may seem obvious. However, giving further thought to the obvious sometimes leads to unexpected discoveries. In this sense, I hope that some of my viewpoints will strike a responsive chord in the reader.

Authenticity

Universality is the first unique quality of the photographic medium, immediacy the second, and authenticity the third. In contrast to other forms of communication, which can never prove that the message is true, a photograph, by its very nature, is evidence: to be able to produce any picture at all, a camera must be an eyewitness to the depicted event. (I realize of course that photographs can be faked; but this possibility does not invalidate the basic concept of photographic authenticity.) The ramifications of this fact are twofold:

A photographer can go all out in his effort to create the strongest possible impression of his subject, secure in the knowledge that, no matter how unorthodox his methods, as long as he works within the framework of phototechnology, that is, disdains unprofessional interference with the photographic image, his pictures will be authentic. This is a very reassuring feeling for anyone, and particularly for a photographer who works in the interest of an unpopular cause, perhaps a fight for social justice, or opposition to a war.

And a person looking at a photograph he does not understand, knowing that it is *ipso facto* authentic, will make an extra effort to get the message of this picture. Confronted with a complex mathematical equation, no sane person would assume that it is gibberish merely because he does not understand it; why not extend the same courtesy to a photograph? This may be particularly necessary in cases where space is represented in an unorthodox form, perhaps in cylindrical or spherical perspective. Making an extra effort to understand such apparently crazy renditions may pay off in the form of added insight on the part of the viewer in regard to the spatial aspects of his world.

Sharpness of rendition

Even the most lovingly executed drawing appears incomplete and crude in comparison with a sharp photograph. The capacity for producing an unbelievable wealth of precisely rendered detail is one of

the basic characteristics of the photographic medium. This can be a blessing as well as a curse. On one hand, it enables a photographer to present his subject in a form that is accurate down to the last minute detail; on the other hand, he may find that the message of his picture got lost in a sea of meaningless trivia.

Photographers aware of these possibilities are in a better position to make good pictures than those who take precision of rendition for granted, lovingly test each new lens for sharpness before they buy it, then make every picture at the smallest possible aperture. Their pictures will be sharp throughout, but this is not the way we see. In human vision the eyes focus sharply on only one subject at a time, the subject we are actively interested in. We are aware of the rest of a scene but perceive it only vaguely. In other words, the eyes work on the principle of selective focus (p. 57). Sharpness is limited to a consciously selected zone, the zone of maximum interest. Now, making the photograph sharp all over spreads the zone of maximum interest over the entire picture area and confuses the eye by depriving it of a plane of sharp focus. Graphically, it means that important and unimportant subject matter are treated alike. The result is inferior pictures.

Experienced photographers know that the camera tends to show too much. If the entire photograph is filled with important subject matter, overall sharpness is probably called for, and the sharper the rendition, the better. However, this is not usually the case. More often, the subject proper fills only a part of the picture. Limiting sharpness of rendition to this particular area by means of selective focus is more likely to give the better result.

Speed of recording

This is another unique characteristic of photography. Where an artist may have to spend minutes on a hasty sketch and hours, days, or months on a complete treatment, a photographer usually needs only a fraction of a second to record an image on film and produce a much more accurate rendition of the subject or event than would have been possible by any other means. The consequences are twofold:

On one hand, moments, expressions, or events that are too fast to be sketched or painted can be recorded photographically. Such occasions can provide a photographer with priceless opportunities to use his camera, if necessary in conjunction with electronic flash, as an instrument for making discoveries in the realm of vision, to show people things that otherwise they would have missed. Of course, the

90

photographer must be aware of the possibility that the moment he chooses to freeze may not be a typical one. In portraiture, for example, not every expression is typical, and some may actually be misleading if taken as clues to character. Here, at least, the painter has the advantage of being able to combine in one portrait many different characteristics he has learned from studying his model. To overcome this disadvantage, a photographer would have to be especially alert during a sitting and make a sufficient number of pictures to be able afterwards to select the most typical ones.

On the other hand, the speed with which the camera records an image is a constant temptation to thoughtless shooting, particularly prevalent in 35mm photography. This practice is based on the assumption that, in accordance with the laws of chance, if only a photographer takes a sufficient number of pictures, one of them must surely come off.

Thoughtless banging away, however, must not be confused with the planned rapid fire of an experienced photographer dealing with a rapidly changing situation, such as a lively portrait session where expressions are changing constantly. In such cases, this kind of shooting is deliberate. Speed of recording is exploited as a means for extracting the most from a short-lived situation. This is perhaps the most significant difference between a beginner and an experienced photographer: Beginners photograph large numbers of subjects incompletely, indiscriminately scattering their shots at the rate of one per subject. In contrast, experienced photographers are selective. They carefully choose a few deserving subjects, then cover each thoroughly with many shots. Both make use of the speed with which the camera produces a picture, both exploit the same characteristic of photography, but with vastly different results.

Color into black-and-white

Photography, as explained before, is not a naturalistic, but a semiabstract medium of rendition, because it depends on symbols—perspective for depth, blur for motion, and so on. Now, since two of reality's most important qualities can effectively be represented by symbols in any still photograph, it should not come as a surprise that a third quality—color—can also be rendered in symbolic form—gray shades—without impairing the validity of the rendition.

Superficially seen, gray shades may seem a poor substitute for color. It may seem particularly pitiful because it is possible to take color pictures. However, if used with proper understanding of the medium,

gray-tone renditions permit a photographer to accomplish results impossible to achieve by any other means:

High contrast is the most powerful means of graphic rendition. No color is as light as white or as dark as black, and nothing makes a stronger impression than black placed next to white.

The contrast range of black-and-white film is considerably more extensive than that of color film. Consequently, high-contrast subjects, which cannot be rendered satisfactorily on color film, can still be effective in photographic form if rendered in black-and-white.

Black-and-white film is subject to contrast control, color film is not. In other words, if he shoots in color, a photographer has to be satisfied with the contrast range of his subject. But if he works in black-and-white, he can increase or decrease the contrast range of the rendition to almost any degree. He can also control contrast on a local scale; that is, he can render specific areas of the picture either lighter, or darker, than they were in the subject. The photographer can do this either by means of color filters while taking the picture, or by dodging while making the print. The ramifications of these possibilities for the making of good photographs should be obvious.

A common problem in telephotography, for example, is how to show a distant subject in sufficiently contrasty form. Consider, for instance, the picture on pp. 142–143. Shot from two miles away on a hazy day, the skyline appeared to the eye as a monochrome in pale blue-gray. On color film, the impression would have been too weak and insipid to do justice to the powerful subject. On black-and-white film, with a deep red filter and paper of extra hard gradation, it turned into a stunning photograph.

If further justification for the continuing use of black-and-white renditions should be necessary, let me remind the reader of the facts that, in art, monochrome and polychrome forms of rendition have existed side by side for centuries without one replacing the other; and that many top photographers, who certainly could afford to work exclusively in color, still prefer to do a large part of their work in black-and-white—precisely because it offers them means of graphic expression that do not exist in color.

Positive into negative

In photography, a negative is normally nothing but a stage in the process of making the positive picture. However, since photography provides the only simple technique for transforming positive images

92

into negative ones, it seems to me that this possibility might be worth closer investigation, particularly by creative photographers in search of new means of graphic expression.

Up to now, the principle of negative rendition has been utilized primarily by industry in the form of blueprints, which show white line drawings against a dark background. Particularly in bright light, white lines on dark are easier to see than dark lines on white. The latter form of rendition is more likely to cause eye-fatigue because of halation. Blueprints prove that a negative rendition can be understood just as easily as a positive one, especially if relatively simple subjects are involved. In photography, negative images have the following advantages over positive ones:

They are still unusual—and the unusual in itself draws more attention than the ordinary. This automatically gives negative prints the eye appeal of which I spoke before and will have to say more later (pp. 16 and 124).

Much clearer than positive images, negative prints show detail within those parts of the subject that are in the shade. In ordinary prints, these areas appear of course dark or black, but they are light, well-detailed, and almost luminous in good negative prints. Where shadow areas are extensive and contain important detail, a negative form of rendition may have a decisive edge over an ordinary print.

Normally, the top side of a subject, because it catches more light, is lighter than its lower parts, which are apt to be in the shade. In negative form, this situation is reversed with the result that the subject seems to glow from within, emanating a soft, mysterious light.

Because we are not used to seeing our world in negative form, we look at negative prints with new eyes. Features normally missed because they are taken for granted may stand out in surprising clarity in a negative picture. Also, structural as well as compositional characteristics of the subject—its skeleton—usually seem more clearly revealed in negative than in positive form.

Bas-relief prints

These are photographic abstractions produced by combining a negative with its diapositive. The two are placed together with their emulsion sides in contact, moved slightly out of register, and enlarged together on extra hard paper. The result is a kind of photographic line drawing. If successful, it can have extraordinary graphic appeal. Although a hundred percent photographic, this technique enables a

photographer to enter the realm of the abstract and create pictures with the simplicity and strength of a woodcut.

Solarization and reticulation

These are two other, typically photographic techniques that enable a photographer to transform naturalistic images into abstractions. How this is done has been discussed in my book *The Complete Photographer* (Thames and Hudson, 1965). I mention these processes because it seems to me that photography, in order to develop and grow, must branch out into new fields. Bas-relief, solarization, and reticulation enable photographers to follow paths like those taken by the modern painters, who abandoned naturalism in favor of abstraction. Whether or not this is a desirable development is not the point. What matters is that it exists, that it cannot be ignored, and that creative photographers should be aware of it. Whether or not they make use of this opportunity and how are up to them.

Transition from light to dark

No other graphic medium (with the possible exception of airbrush technique) is capable of producing shadings and transitions from light to dark as continuous, delicate, and smooth as photography. As a result, a photograph can convey illusions of roundness, volume, and depth rarely achieved by any other medium and surpassed by none.

On the other hand, photography is equally capable of yielding tonal transitions that, due to high contrast and a coarse, sandpaper-like texture, or *grain*, have an appeal all their own, immensely suited to producing illusions of harsh reality and suggesting the coarser aspects of modern life.

Whereas the first effect is brought about by working with a relatively large negative format in conjunction with low-contrast development and printing on a relatively soft paper, the second is produced by using a small negative format, high-speed film, and enlarging on paper of relatively hard gradation. That these two processes are not interchangeable—that the same subject cannot possibly appear equally effective in both a smooth and a coarse rendition—should be obvious to any sensitive photographer.

Equally obvious is that a photographer who hopes to make good pictures must make up his mind whether a smooth or a coarse rendition would be more in character with the nature of his subject, and then proceed accordingly.

94

Close-up to infinity

The range of human vision is severely restricted. At distances shorter than approximately eight inches, sharp vision gives way to blur. With increasing distance, objects appear progressively smaller and detail less distinct. Objects that are too close, too far away, or too small cannot be seen at all. In contrast, the camera used if necessary in conjunction with the microscope or the telescope, can portray anything at virtually any distance in nearly any scale.

This almost unlimited vision of the camera is one of the most valuable characteristics of photography, because it amounts to an extension of our own sense of sight. As far as the average photographer is concerned, it means that even with relatively inexpensive cameras, used with extension tubes or bellows and telephoto lenses or tele-extenders, small objects can be shown in ten or more times natural size, and distant objects brought closer by a factor of ten or more. No aware photographer will leave such possibilities unexplored.

Wide to narrow angle of view

Whereas the angle of human vision is fixed, the angle of view of the camera is variable, its scope depending on the kind of lens which was used. In conjunction with a 35mm camera, for example, a 1000mm telephoto lens encompasses an angle of less than 5 degrees. A fish-eye lens yields one of 180 or more degrees. To visualize what this means, imagine you have a camera equipped with a fish-eye lens hanging from a strap around your neck, lens pointing forward. Then stand straight, extend your arms horizontally until your fingertips point in opposite directions, and let a friend release the shutter of your camera. The resulting picture, in addition to showing everything you saw, would also include your nose, your feet, and the fingers of both your hands. The perspective of such a superduper wide-angle shot would, of course, be spherical, a form of spatial rendition already discussed. By carefully selecting their lenses in accordance with the intended result, creative photographers exploit this variability of camera vision to make pictures that are more to the point and more significant.

Light-accumulating capacity

Unlike the human eye, which sees proportionally less as the level of illumination decreases, photographic emulsions are able to produce strong images as long as there is any light at all, if only they receive a

sufficiently extended exposure. Unlike the human eye, photographic film is capable of adding minute quantities of light and continuing to add until the cumulative effect is strong enough to produce a usable image. It is this unique light-accumulating power that enables astronomers to photograph stars and galaxies too faint to be seen by any human eye, even through the largest telescopes. To ordinary photographers, this typically photographic quality is normally of little interest except in the following connection:

At night, fully detailed negatives can be produced by correspondingly long exposures. As a matter of fact, even on the darkest night, as long as there is any light at all, a photograph can be overexposed with the result that the picture contains as much detail as if it had been made by daylight. Needless to say, this invalidates the mood of mystery that we associate with night.

Multiple images

Whereas the eye can receive and the brain process only one image at a time, the camera can combine in the form of a single view as many pictures as the photographer desires. The techniques by which he achieves these results are multiple exposure, multiple printing, and time exposure by stroboscopic light. Certain types of ordinary time exposures—those in which the subject moves during the exposure— also belong in this category insofar as they show the subject in the form of a blur. This form of directional blur consists of an infinite number of overlapping images strung out in the direction in which the subject moved.

Normally, of course, double exposure is a mistake that should be avoided. Appropriately applied by a photographer who knows what he is doing, however, multiple images open up new vistas, showing us things we otherwise could not see, disclosing new worlds of fantasy. In painting, artists like Braque, Picasso, and Magritte discovered long ago the psychological impact of multiple images and used this principle extensively. In photography, Dr. Harold Edgerton's picture of a golfer swinging his club and Gjon Mili's nude descending a staircase, both taken by stroboscopic light, are examples of multiple-picture imagery familiar to every visually literate photographer. From here to combining two or more separate but psychologically related subjects in one picture is only one step—but a step which takes a photographer from the world of reality into the realm of fantasy.

Invisible radiation

The eye is sensitive only to the narrow band of electromagnetic radiation that we perceive as light, but film can also be sensitized to certain invisible forms of radiation, specifically short-wave X rays and ultraviolet, and long-wave infrared and radiant heat. Since the properties of these forms of radiation are totally different from those of light, photographs taken with their aid are unlike anything the human eye has ever seen. As a result, photographers can now depict phenomena that previously were invisible.

Although the practical applications of these films are of interest mainly to specialists, at least one group—the infrared-sensitized films— have potential value also to experimentally inclined, nonscientific photographers. These films are available in both black-and-white and color. They can penetrate atmospheric haze (a boon to telephotography); allow a photographer to take pictures in total darkness by the "black light" emitted by specially coated infrared flashbulbs; and, in color photography, render green foliage red—to mention only their most outstanding features. Creative photographers should have no difficulty finding other applications for these films.

Undesirable characteristics in black-and-white photography

In the black-and-white photograph, colors of equal brightness, no matter how different their hues, are represented by equal shades of gray. As a result, subjects that in reality were colorful, bright, and gay, lose their main characteristic in black-and-white and appear drab and monotonous. Such pictures, of course, are totally ineffective. To avoid this possibility, either a photographer must achieve satisfactory color separation by means of filtration (p. 53) and simultaneously translate the dominant colors of the subject into psychologically effective shades of gray; or he must use color film instead of black-and-white; or he can abstain from making the picture.

Undesirable characteristics in color photography

The contrast range of color film is considerably more limited than in black-and-white photography. As a result, subjects in which contrast is high are basically unsuitable for rendition in color, because, surprising though this may sound, underexposure and overexposure may occur within the same transparency: The lightest areas can be overexposed and their colors burned out, while the darkest areas are

underexposed and appear as solid black. If faced with this kind of subject, the best a photographer can normally do is expose in such a way that the lightest areas still show color even though this means sacrificing detail in the darkest areas. Reversing this approach and exposing for detail in the darkest areas while letting the lightest areas burn out is generally less likely to produce acceptable results. Still another alternative—and often the best—is to make the shot on black-and-white instead of color film. If this is not feasible, abstaining from making the picture is, at least in my opinion, preferable to making a bad photograph.

Undesirable characteristics in general photography

Human vision is stereoscopic; camera vision is monoscopic (monocular). Failure to pay attention to this fundamental difference is the main reason why so many photographs appear flat. Seeing his subject in depth, the photographer forgets to allow for the camera's inability to translate depth literally into picture form. To create the illusion of three-dimensionality in a photograph, depth must be expressed in symbolic form. How this can be done was explained earlier (p. 76). The fact that special stereo cameras exist that automatically yield pictures that seem to have depth does not alter this principle.

Reality is ever-changing, in constant flux and motion, but a photograph is a "still." Failure to allow for this difference is the reason why so many photographs appear awkward, stiff, and dead. Like depth, motion cannot be rendered directly in a still picture. If motion is a subject characteristic that must be conveyed by the photograph, it must be indicated in symbolic form. The principles by which this can be done have already been mentioned (p. 77).

Modern cameras are so sophisticated, so highly automated, and supplemented by so large a variety of auxiliary devices that nothing tangible exists today that cannot be photographed. This fact apparently has gone to the head of many a photographer who seriously believes that all he has to do is to aim his camera at the subject, focus sharply, line up the needle of the exposure meter, release the shutter without jarring the works, and presto!—he gets a perfect picture. That most of these pictures fail to convey the essence of the subject is simply accepted by many people as one of the facts of photographic life. After all, they say, a photograph has nothing to do with art. What these people forget is that even the most highly automated camera is nothing but a tool, analogous to the piano of the concert pianist, the brush of

98

the painter, or the typewriter of the novelist; that a tool cannot think but merely performs in accordance with the will and capability of its master; and that, in photography, it is still the creative mind that chooses the subject, decides the manner of approach, selects the form of rendition, and guides the eye, the hand, and the tool.

CONCLUSIONS

Like any other art or craft, photography has its scope and limitations. These are determined by the characteristics of the medium and can be summed up as follows:

A camera is a machine, and its product, the photograph, is a true or literal translation of reality into picture form. However, as I have tried to show, a literal translation is not necessarily a good one. Going back to my analogy with music, we might say that any child can strike notes on the piano and learn to play a simple tune; but this is not exactly what we understand by music. Similarly, anybody can take a snap and produce a recognizable picture; but such snapshots are not necessarily meaningful and interesting. To be able to make good photographs, a photographer must be familiar with the potential and limitations of the photographic process and be versed in its techniques, just as a pianist can make good music only if he is familiar with the potential and limitations of the piano and has learned to play it well.

Still more, however, is required before a photographer can consistently make good photographs: discrimination. For no matter how accomplished the pianist, if the score that he chooses to play is vulgar or dull, not even his best efforts can make the music good. And no matter how accomplished a photographer, if the subject he chooses for rendition is trite or meaningless, not even the most accomplished phototechnique can turn it into a good picture. As I said before and want to repeat here for emphasis, in photography,

know-how is useless unless guided by know-why.

V. A Personal Approach
to Photography

To a photographer, photography is a way of life. But since people are different, different photographers see different things in photography. To many, it is a challenging and fascinating way of making a living; these are the professional photographers and photojournalists. To others, it is a hobby, a source of pleasure, relaxation, and fun; most amateurs belong to this group. Some see in photography a means for informing and educating people and ultimately bettering their lives; Jacob A. Riis and Lewis W. Hine took this kind of idealistic, social-reform approach. And then there are those who find in photography the ideal outlet for self-expression; the not-quite-artists, who are compelled to create and share their views with their fellow men; this is the group to which I belong.

I am convinced that a photographer can achieve fulfillment only if he finds his proper niche in photography; otherwise, disenchantment is inevitable. Consequently, the first thing anyone who seriously contemplates a life in photography should do in order to assure his future satisfaction is to ask himself three questions:

Why do I wish to photograph?
How do I wish to photograph?
What do I wish to photograph?

Only on the basis of the answers to these questions can he chart his future course and find the road to satisfaction and success. Photography is an intensely personal affair, and each photographer must find his own approach.

Since it is possible to speak meaningfully only about personal experiences, I give in the following an account of my own attitude toward photography, hoping that the reader will find it helpful as a guide when he considers his own approach.

100

WHY DO I WISH TO PHOTOGRAPH?

Bluntly speaking, I photograph because I believe I have something to say that is of interest to other people; and being a visually oriented person, I prefer to say it in the form of pictures rather than with words. Also, because photography is the universal picture language of the world, photographs are understood globally, while words are not. And since I make my pictures for the benefit of other people, I naturally want the largest possible audience for my work.

However, much more is involved than what at first may sound like the words of an egomaniac—intangibles, feelings, compulsions. Perhaps I can explain myself best by quoting from *The Creative Photographer* (Prentice-Hall, 1955), where I gave an analysis of my motivations that I still consider valid:

> The contribution which photography has made to our common wealth of knowledge and experience is incalculable, and every photographer is a potential contributor. The urge to contribute is one of the roots of the creative drive which, to a greater or lesser extent, exists in everyone. We all have the desire to do something worthwhile, something that lifts us out of our everyday anonymity, something by which we might be remembered and achieve a kind of immortality. The scale on which we work is immaterial, and so is the field in which we make our contribution, each contributing to the best of his ability. Our civilization is built on such foundation. We all learn from one another, from those who preceded us, the heritage they left—knowledge, teachings, ideas, art. Without the creative spirit of those who gave us this we would still be living in caves, each laboriously making his own little discoveries, each starting anew. No aware person can fail to acknowledge the enormous debt he owes to those from which he learned. The only way of repaying this debt is to preserve the continuity and add his own contribution to the common fund. As a photographer whom chance has given unusual opportunities and deeply aware of the degree to which my own success is built upon the struggles of others, I make my photographs in payment of my debt.*

But even this analysis explains only partly why I wish to photograph or, more precisely, why I *have* to photograph, for

*Reprinted by permission.

compulsion is involved, the drive to create. I simply cannot see certain things without becoming intensely involved. I have to express myself and share my views and findings with others. Again I can do no better than quote a passage that I wrote almost twenty years ago in *The Creative Photographer:*

> One of the most mysterious forces in man is the drive to create —the urge to make things which are beyond the basic needs of life. The highest animals show no evidence of this force; but we find it manifested already in prehistoric man who, some twenty thousand years ago, painted the murals in the caves of Altamira and Lascaux.

> It is this force which created our culture. I have seen it at work in others, I have felt it in myself. It defies analysis and reason. It is simply there, as elementary as the drives of hunger and sex, and it demands release.

> It is this urge to create which forces the artist to paint, to try again and again for something that always seems to elude his grasp, to persist, no matter how painful the struggle, how terrible the frustration when the hand is unable to give form to what the mind sees so clearly. It drove Gauguin from family and home; it drove Van Gogh into insanity. It created the masterpieces of art.

> And, although the level may be different, it is this compulsion to create to which we owe great photographs. It explains why photographers work like slaves and sometimes, like Robert Capa, Werner Bishof, and Larry Burrows, literally die in an attempt to accomplish something which no one essentially cares about. Why do they do it, and for what? Consider the photo-journalist's case: for days, weeks, sometimes for months, he works, often under conditions of incredible hardship—in steaming jungles, in the cold of the arctic, in blizzards and tropical heat, in the unimaginable loneliness of the stratosphere, risking his life in war —for what? Not for money, for he could stay at home and earn much more in advertising. Not for fame, for a magazine copy's life is almost as short as that of a newspaper; few save it for future reference, although it documents the history of our time. No, we do this kind of work and lead this kind of life because we have to. We could not function otherwise because we are possessed by the compulsion to create.

> We do our work in the only way in which we can do it—the right way, the perfectionist's way, the hard way—because creative man is compelled to drive forward, contributing his share to the

slow progress of the race, hoping, believing consciously or unconsciously, that tomorrow will bring a better day.

Nature is wasteful on a gigantic scale because she can afford it. An immense number of lives are sacrificed for every one that survives to fulfill its destiny. But man cannot follow such a course if he expects to survive. No one will ever know the number of talents crushed before they had a chance to develop, to mature, to give to all of us—victims of a system devoted almost exclusively to the creation of material wealth. How many potential Beethovens and Van Goghs have been lost to humanity because their aspirations were submerged in the struggle for bodily survival? How many have been killed in war? How much longer can we afford to waste our most valuable resources in this criminal way?

Anyone who feels in himself the spark of creative power is dutybound to keep it alive, to feed it, to develop it until the time comes when he can give, adding his contribution, be it ever so small, to the cultural heritage of man.*

This, I believe, is the real reason why I photograph.

HOW DO I WISH TO PHOTOGRAPH?

The way I see it, the choice is between two basically different forms of photography: objective and subjective. Both have already been discussed (pp. 22–23). I myself have taken an intermediate course in my work, trying to combine the most desirable features of each. On the one hand, having a scientist's attitude toward accuracy and truth, I try to be as precise in my photography as possible, striving for the utmost in sharpness, order, and informative values. On the other hand, my artistic training never lets me forget the importance of an aesthetically satisfying form of presentation. As a result, I give much thought to such matters as choice of the most suitable photographic symbols, selection of the most advantageous photographic equipment and techniques, graphic eye appeal, and composition. Since this includes a striving for highest phototechnical quality, I always use the

*Reprinted by permission.

largest film size which I can use in a given case without sacrificing other desirable objectives like immediacy or spontaneity. This is one reason why I make the majority of my photographs with view cameras; the other reason being that most of my subjects are static. Nowadays, of course, most photographs regardless of subject matter are made with a 35mm single-lens reflex camera. The ease with which this type of camera produces pictures invites indiscriminate shooting, a fact that doubtless is at least partly responsible for the general deterioration of photographic standards. Lack of the technical skill and care necessary to produce high-quality 35mm work does the rest. The results, of course, are the familiar fuzzy, grainy, meaningless pictures we see so often. Their makers obviously did not give much thought to the problem of *how* they wanted to photograph.

To find out how he really should photograph, a striving photographer must take into account three points:

The personality of the photographer
The nature of the subject
The purpose of the picture

The personality of the photographer

The attitude and demands of a slow and careful worker are different from those of a spontaneous and impulsive one. In photography, this means that a slow and careful worker is probably more interested in highest possible picture quality than in spontaneity of expression and life. Practically, this means that the deliberate person should work with a $2^{1}/_{4}'' \times 2^{1}/_{4}''$ or larger camera; the impulsive worker should use a 35mm camera. Otherwise, personality and tool will constantly be in conflict. The small camera would be unable to give the careful worker the picture quality he demands; the larger camera would prevent the impulsive worker from achieving in his photographs that feeling of spontaneity that means so much to him. In my opinion, acquisition of the wrong type of camera—selection of the wrong tool—is as disastrous in photography as in any other craft and a common cause of disappointment on the part of the photographer.

(Text continued on p. 113)

104

Inside the torch of the Statue of Liberty, by *John Veltri*. It requires an observant eye to notice a subject as unusual, interesting, photogenic, and graphically satisfactory as this. How a photographer can train himself in this respect has been discussed on pp. 130-133. Note, in the picture above, how the use of black and white in a color photograph increases the range of contrast of the rendition without involving the danger of overexposing very light or underexposing very dark colors since it is obviously impossible to overexpose white or underexpose black. At the same time, black, in contrast to its own darkness, makes color appear more luminous; white, in contrast to its own lightness, gives color added depth.

105

Young girl, two photographs by *John Veltri*. I deliberately show here two versions of the same subject shot in rapid succession to illustrate that, normally, there is not necessarily *only one* "perfect photograph." Why? Because, obviously, any subject has many different sides and aspects and can be photographed in many different ways. Which one of the two versions

presented here does the reader prefer? Personally, I can't decide between the two; to me, each is perfect in its own way. Conclusion: If you encounter a "perfect" subject, explore it thoroughly with the camera—a lucky chance is a one-time thing.

Doorway in Athens, and **Portrait of a girl,** by *John Veltri*. The "stopping power" (pp. 124–126) of these two photographs lies in the fact that the first contains an unusual amount of white for a color picture, and that the second one is abnormally dark. In each, however, the respective quality is not a "gimmick" but an essential aspect of the subject and indispensable to the

impression which the photographer intended to create. Although both subjects would also have been effective in black-and-white, in my opinion the use of color adds a further dimension with the result that I consider these pictures not merely ''good'' but ''perfect.''

Above: **Black is beautiful;** *opposite:* **Scare-crow,** both by *John Veltri.* The distinguishing aspect of these photographs is the restrained use of color, effectively refuting the claim of certain "experts" that subjects that are not "colorful" enough don't deserve to be shot in color. In my opinion, precisely the opposite is true: as a rule, subjects characterized by subtle colors, related colors, or harmonious colors are much more effective in the form of color photographs than subjects displaying too many different colors which easily appear gaudy and "cheap."

End of the hunt, by *Andreas Feininger.* More than almost any other kind of subject, colorful sunsets demand to be shot in color if the photograph is to be "perfect." However, for best results, it is imperative that the exposure is on the short rather than the long side: a decrease in exposure produces darker, more saturated colors; conversely, increases in exposure produce colors of increasing lightness which easily appear "washed out"—the last thing one wants to see in a sunset sky.

The nature of the subject

Basically, static subjects—subjects that are inanimate and hold still —should be photographed with a larger camera than dynamic subjects —subject that are alive or in motion. In the first case, phototechnically higher quality can be achieved with a larger camera than with a smaller one, and the slight inconvenience of somewhat lower speed of operation and greater bulk and weight is usually inconsequential. In the second case, only a small, fast, inconspicuous camera is normally capable of producing the desired result, the price of which may have to be a loss in picture quality. If both static and dynamic subjects should be photographed, the best solution is two cameras of different size; alternatively, a photographer can compromise by using one camera of medium size for both.

The purpose of the picture

It obviously makes a difference whether a photograph is intended to illustrate a scientific report or an article in a general magazine, or to try to explore the ultimate limits of the medium. In the first case, scientific illustration, a strictly factual approach is needed; in the last case, exploring the limits of photography, a completely imaginative and free subject approach is indicated; in the second case, general magazine photography, an essentially factual but graphically imaginative approach would probably yield the most rewarding result. In other words, the purposes of pictures vary; and this will play a decisive role in a photographer's decision *how* to photograph.

Conclusion

The *how* of photography is decided by a combination of factors: the personality of the photographer, the nature of the subject, the purpose of the picture, the type of tool, and the specific techniques involved. Since these factors are not always compatible, it is the skill with which a photographer is able to arrange a compromise that decides whether or not his picture has a chance to be good.

WHAT DO I WISH TO PHOTOGRAPH?

During my twenty years of work as a photographer for *Life* I invariably found that the quality of a photographer's work was directly proportional to the interest he took in his subject. Good picture editors know this and prefer to assign photographers to cover subjects that they like. In this respect, amateurs are even better off than professionals, because they are free to photograph whatever subject interests them most. Unfortunately, not all amateurs take advantage of this priceless opportunity of choice. Instead of pursuing their own course, they follow trends and fashions, listen to the voices at the photo club, or imitate the work of other photographers whom they admire. In other words, they give up their prerogative to be photographers in their own right, abdicate their individuality, and conform. This puts an end to all creative aspirations.

In my opinion, photographers who have to ask what they should photograph are to be pitied. They are not what I call "photographers" —people who use photography as a means to an end, the way a writer uses words: to communicate with other people. They have fallen in love with shiny gadgets; they have succumbed to the prestige associated with expensive cameras; they enjoy playing the role of a photographer, which they consider glamorous. They endlessly test their lenses for sharpness and their developers for graininess; they are walking encyclopedias as far as photo lore is concerned; they own the finest photographic equipment and are proudest of the fact that they can make grainless blowups from 35mm negatives. But they never make a worthwhile picture.

In contrast to these pseudo-photographers, real photographers, paradoxical as this may sound, are interested in photography only to a point; their real interest is in their subjects. They are fascinated by people, faces, social problems, girls, insects, birds, bats, hiking, you name it. And because they are intensely involved with certain types of subject or activity, they have to make pictures of the things they love, *because by this they can possess them.* Photography enables them to annihilate space and arrest time, to bring the Taj Mahal into their home, to preserve forever the beauty of a loved face or the memory of golden days, or to share their feelings with others. And *only* because a good picture does this better than a mediocre one do they become involved with the technical and artistic intricacies of photography,

because they have discovered that the photograph of a beautiful subject is not *ipso facto* a beautiful photograph. Beautiful, effective, and memorable pictures—in short, good photographs—are made only by people who understand the characteristics, potential, and limitations of the photographic medium.

Consequently, the problem of what to photograph boils down to a simple question: What kind of subject are you interested in? What do you want to preserve in picture form, take home with you, contemplate again and again, or share with other people? And never mind the other guy, his favorite subjects, his hang-ups. Each person is different from any other. Therefore, no matter how unusual your interests, go right ahead, pursue them to the very end. And no matter how rare your subject, somewhere there is someone who shares your interest, with whom you can communicate. To go ahead and do what you are compelled to do, in your own way, with conviction and pride is the only way to fulfillment in photography.

MY OWN APPROACH TO PHOTOGRAPHY

My approach to photography is based on the conviction that a photograph is primarily a means of communication and the camera potentially a means for making discoveries in the realm of vision, analogous to the microscope and the telescope. Furthermore, since I am convinced that photography is *not* a naturalistic medium of reproduction, I see no point in striving for a literal translation of reality into picture form. At best, this produces only record shots, which show me nothing I could not have seen just as well, and often better, directly with my eyes. Instead, I try to take advantage of all the fabulous potentialities inherent in the photographic medium. I use it deliberately as a priceless extension of my vision, as a means of exploring my world, as an opportunity to enrich my life and widen my visual horizons, and ultimately as a disseminator of information and truth as I see it.

In my experience, the process of making a photograph starts with a moment of insight or a flash of inspiration, sparked by visual contact with a subject that caught my interest. Instantly, images begin to form in my mind—not the images I see in front of my eyes, but images on

115

film and sensitized paper, potentialities of the subject, finished photographs. I believe that making any meaningful photograph involves five stages, each equally important for ultimate success:

<div align="center">

Interest in the subject
Understanding of the subject
Evaluation of the subject
Planning the picture
Executing the picture

</div>

Interest in the subject

Interest in the subject—the reason for making the picture—is the spark that energizes the photographer's creative powers. This is the moment of conception. Visions arise, images take shape in the photographer's mind, the idea for a picture is born. Interest engenders enthusiasm, without which the entire process of picturemaking sinks to the level of mechanical routine. My advice to the reader: Unless you really like a subject, forget it.

Understanding of the subject

Interest provokes curiosity, the desire to know more about the subject, which leads in turn to understanding. The photographer takes a closer look at his subject—literally as well as figuratively speaking. Not only does he study it physically for form, structure, color, light, and so on, but also in regard to its purpose, function, ramifications, and so on, until he understands it. Understanding provides the intellectual and emotional basis for the picture, furnishing the facts and feelings the photographer must capture with his camera and convey to the viewer of the picture to be made. Without a proper understanding of the subject, meaningful photographs cannot be made.

Evaluation of the subject

On the basis of understanding, the photographer is able to respond to the subject in personal terms. He reacts, he draws specific conclusions, he forms an opinion, he arrives at a point of view. It is at this stage that he can make the contribution of which I spoke before (p. 101). When a valid personal view is presented in a form that is individual and new, the result is bound to provide the viewer not only with visual stimulation, but also with insight and food for thought.

116

Planning the picture

This is the moment when phototechnical aspects must be considered: How can the photographer best translate reality into the picture language of photography? How should he symbolize subject qualities like depth or motion which cannot be rendered directly in photographic form? How can he convey intangible qualities, feelings, emotions, thought? He can do all this by analyzing his subject in terms of photography, by seeing it *not* in human terms—"This is a girl, a house, a tree"—*but* through the eye of the camera: in terms of two-dimensionality, outline, and form, background and foreground, contrast, light and dark, color relationships and harmonies, different shades of gray, and sharpness, unsharpness, and blur. These are the symbols of photography with which a photographer must familiarize himself so that he can choose the most suitable ones, as a writer who, from the welter of synonyms, chooses each word with care.

Executing the picture

This, the mechanical stage, is the final step in the process of making a picture. The photographer, having decided what to show and how to show it, must now assemble the equipment best suited to translate his visions into picture form. Experienced photographers consider this the easiest of the five stages, automatically reaching for the camera that is best in size and design, the lens with the proper aperture and focal length, the filter in the right color, the film with the most desirable characteristics. They also know that exposing, developing, and printing can be reduced to a science, where control instruments and dial readings have largely replaced the need for craftsman-like skills. In this age of automation, anyone who can read and follow simple instructions should also be able to produce technically perfect negatives, transparencies, and prints.

CONCLUSION

Although each of these five stages is equally vital to the outcome of the picture, few photographers realize the importance of the first four, and many do not even know that they exist. As far as they are concerned, creation of the picture takes place at the moment of exposure. Actually, of course, this moment signifies the end of the

creative process that takes place during stages one to four. Only prior to this fateful moment can a photographer make all the important decisions—select and reject; arrange and change; add or take away; clarify, emphasize, and condense; improve and simplify; control the relationship of subject, background, and foreground; choose subject distance and direction of view; select the most suitable camera, the lens with the most suitable focal length, the film with the most suitable characteristics; choose the shutter speed and diaphragm stop that are just right as far as motion rendition and sharpness in depth are concerned; and so on. But once the shutter has been released, all these influences on the outcome of a photograph are fixed. The die is cast, for better or worse. The rest can be done by any skilled technician.

Regrettably, however, it is stage five with which the average photographer is most concerned. This explains why so many photographs are dull and meaningless. The creative phase—steps one to four—has been neglected; chance is substituted for choice. Such pictures may still be unassailable as far as phototechnical aspects are concerned, but as a source of enjoyment and stimulation they are useless, proving once again that, in photography,

know-how is useless unless guided by know-why.

VI. The Qualities of a Good Photograph

Up to now, I have listed and defined systematically those aspects of photography that must be considered by anyone who seriously tries to make good photographs. In this chapter, I am going to attack this problem from the other end: I will report on the conclusions at which I arrived after having analyzed a large number of pictures that I liked. Invariably, each had these qualities:

> **Purpose and meaning**
> **Emotional impact**
> **Stopping power**
> **Graphic quality**

Conversely, photographs that didn't impress me failed without exception in several or all of these respects. The more obvious the absence of these qualities, the poorer the picture. Photographers who are seriously concerned about raising the level of their work should therefore pay careful attention to these aspects, which are discussed below.

PURPOSE AND MEANING

Whenever I speak in the following of *purpose,* I mean the intentions of the photographer—the *why* of photography; and when I speak of *meaning,* I refer to the content, or message, of the picture— the *what* of photography. The purpose of a photograph may be, for example, educational; the photographer intends to teach the viewer of the picture something, say, knitting. The meaning of the picture may be to explain a specific step in making a sweater, perhaps a complicated stitch. Now, it is quite possible for the purpose of the picture to be clear although the meaning is not, *i.e.,* the photograph

may be taken in such a way that it is confusing. In other words, purpose and meaning are not the same as far as a photographer is concerned and must be considered separately.

The purpose of a photograph

It can be almost anything. It may have been made to inform the viewer of a magazine, educate a student, sell a product, or make a political candidate look better than he really is. It may be an appeal to the heart, soliciting contributions to charity. Or the photographer may intend to entertain the viewer, say, with pin-up girls or nudes. Or he may simply want to make a record of a happy moment in his life. Again, it is not so much the what that counts, but the why. For as long as he reaches for the camera with a specific idea in mind, he can never go totally wrong. No matter how inept the realization of this idea, it somehow will come through. It is the mindlessly shot photograph that unfailingly is bad. Consequently, the first thing a photographer should do every time he reaches for the camera is to ask himself:

Precisely, why do I want to make this photograph?

And not before he has defined the purpose of the intended picture as precisely as possible, not just in vague and general terms, should he go ahead and, on the basis of this analysis, plan the execution of the photograph in terms of artistic and phototechnical considerations. This is the moment when the basis for success or failure is laid.

The meaning of a photograph

This is its message, what the photographer wanted to say with his picture. If a photograph means something to somebody, it is valid; if it doesn't, it is valueless. Obviously, the first kind is justified, no matter how deficient it may be in other respects; but the second type, even if it is executed brilliantly in phototechnical respects, is nothing. It is a glittering but empty shell, an exercise in futility as senseless as scratching the Lord's prayer on the head of a pin.

In my opinion, a meaningful but poorly executed photograph is comparable to a book which, though badly written, has something of interest to say. No matter how clumsily expressed, if the thought in the mind of the writer (or the idea of the photographer) is valid, stimulating, or new, the reader (or viewer) will respond. He will feel

120

he got something out of the work, he will profit, even though the process of extraction may have been painful. But if, after reading the book (or contemplating the picture), he feels he has wasted his time, he will feel cheated. Consequently, the question a photographer must ask himself after he has established the purpose of his contemplated picture should be:

Precisely, what do I want this photograph to say?

Like its purpose, the meaning of a photograph can be almost anything. In most cases, provided, of course, there is a meaning, the meaning of a photograph will be clear. However, there are certain types of pictures—particularly the experimental or symbolic ones—whose meaning is obscure, although their purpose is not. As when reading modern poetry or looking at abstract modern painting, the viewer, if he wants to penetrate beyond the obvious, may have to make a conscious effort before he gets the message. That this may not have to be a waste of time is proven by the example of the monotonous Cape Cod landscape, of which I spoke earlier (p. 17). In other instances, of course, the viewer may never understand the picture and give up, or there may have been no message. This is a risk that anybody actively interested in new concepts must take.

Obviously, then, no rules exist to guide the photographer who wishes to give his pictures meaning. Everybody is on his own, although I may be able to give him a clue: As long as a photographer makes pictures *because he is interested in the subject*, his photographs will have meaning, at least to him and probably to certain other people, too. Only if he picks a subject merely because he thinks it will make a good picture—perhaps remembering similar photographs from books or photoshows—will he fail, because this kind of aimless subject approach leads nowhere.

Familiar examples of this kind of so-what photograph are stacks of lobster pots on a wharf; the white church in the valley; nude girls bravely trying to look unconcerned no matter how stilted and contrived the pose forced upon them by the photographer; still lifes consisting of plates of spun aluminum, a pitcher, and a bunch of grapes; bearded bums dressed in burlap pretending to be monks; gnarled hands clutching a Bible, with perhaps a pair of old-fashioned spectacles and a candle to keep them company; the winding brook or country road

forming an S-curve; pattern shots of any kind and description—the tired photographic clichés. Or their modern equivalents: the subject shot with a fish-eye lens when this is the last type of lens that should have been used; the zoomed time exposure of a girl or a face; the colored gels used indiscriminately in front of photolamps; the zebra-striped nude; the "interesting" distortions—heads the size of basketballs, enormous hands or feet; the multiple exposure senselessly repeating the same subject in different colors; the color posterization made only because the photographer felt it was "the thing" to play with Kodalith. If the reader knows his history, he knows that the story of photographic clichés is a long one: In Stieglitz's time, a photograph had to be softly diffused in order to be considered good; the $f/64$ School headed by Edward Weston decreed that it must be razor-sharp throughout. Bird's-eye and worm's-eye views were the rage of the late twenties, when everything had to be shot at an angle. And it was not too long ago that a picture had to be made by available light to be acceptable to the in-crowd.

No photograph exists, of course, which has meaning for everybody, and photographers who try to please all end up by pleasing none. My advice to the reader: Think before you shoot, then do what you believe is right. As long as your work is the outcome of honest conviction, it is valid, and your pictures will be meaningful.

EMOTIONAL IMPACT

Whereas the purpose and meaning of a photograph are directed toward the intellectual faculties of the viewer, emotional impact is aimed at his heart. And while the object of purpose and meaning is to inform the viewer, the object of emotional impact is to make him feel.

The feelings evoked by good photographs can range all the way from the sublime to the vulgar, from compassion and love of humanity to hatred and prurient desire. Naturally, not every photograph that has emotional impact is good; but just as surely, a photograph that does not elicit an emotional reaction is automatically a failure, unless it is simply a record shot or a statement of fact (as in scientific, textbook, or catalogue photography) in which case no emotional effect is required.

Emotional impact is an elusive quality, whose absence is often more noticeable than its presence. If a photograph leaves the viewer cold, it lacks emotional impact, at least as far as he is concerned. If, on the other hand, it makes him react, if it makes him feel happy, proud, nostalgic, sad, compassionate, if it makes him laugh or cry, if it stirs his anger or sexual desire, in short, if it makes him experience anything beyond the immediate physical aspects of the depicted subject, then it has emotional impact.

The value of emotional impact is obvious in certain types of photograph, for example, pictures used for a charity drive. It is less obvious in others, like photographs of automobiles or washing machines in advertisements. But even in such cases, emotional impact is a valuable quality, because it can make the product appear more desirable—and desire is the essence of advertising.

Prerequisite for the creation of emotional impact in photographic form is involvement on the part of the photographer. Unless he himself feels the particular emotion he wants to convey through his picture, unless he responds to his subject emotionally, he cannot symbolize this quality in photographic form. As a matter of fact, he probably wouldn't even know which feeling to portray, since he himself felt nothing. For example, how can anybody evoke the feeling of beauty in a portrait unless he sees the beauty in this face? True beauty is more than regularity of features or a flawless skin; it is the combined result of personality and warmth and compassion and honesty and pride and other human qualities, which find their expression in a smile, in the way a person looks at you, and in the language of the body. It is the presence of these qualities that makes it possible for an ugly woman to be beautiful, while their absence, at least in my opinion, makes even the most gorgeous woman look ugly. Proof that this is true is evident in every photograph of an old and wrinkled face that shines with goodness and is beautiful, whereas the slickly retouched portraits made by some of the most famous names in photography look like types—corporation heads, bankers, doctors, and so on—instead of individual people. Elimination of all traces of individuality and life made them ugly; to me, they might just as well be pictures of skilfully embalmed corpses.

Which brings me to another prerequisite for the creation of emotional impact in photography: honesty. There is no getting away from it. An honest statement, whether in the form of pictures or words,

has a power of conviction all of its own, an emotional impact that a faked or phony rendition can never have. I have even found that this reaction to anything that suggests or resembles faking carries over into the technical aspects of a photograph. For example, I notice that photographs of violent events, such as war, riots, disasters, affected me more strongly if the picture was technically imperfect—grainy, unsharp, or blurred—than shots of similar subjects that were technically immaculate—smooth and sharp. My explanation of this phenomenon—and this may come as a shock to those who are naive enough to judge the value of a photograph by its degree of technical perfection—is that coarseness of rendition somehow suggests danger, the need for haste and therefore sloppy work, as if there had been no time to do a perfect job. Or conversely, if there was time enough for the photographer to do a technically perfect job, things couldn't have been quite as bad as they seemed. This is a psychological reaction which, I believe, contains a lesson to any sensitive photographer: Be skeptical of any rules in photography. Listen carefully, but draw your own conclusions, because what ordinarily is considered a fault of the picture may, on occasion, turn out to be a virtue.

STOPPING POWER

I mentioned before that people generally pay scant attention to ordinary photographs, because they are sated with pictures, and that an unnoticed picture is a wasted effort, its purpose unfulfilled, its message lost. Therefore, one of the prime requisites of any good photograph is stopping power.

Stopping power is eye appeal—that aspect of a photograph that commands attention. Now, I don't want to imply that the presence of stopping power automatically makes a photograph good, nor that its absence makes an otherwise good picture bad. What I want to say is that a good photograph without stopping power is more likely to be overlooked and thus wasted than another, equally good but not necessarily better picture that has this useful quality.

124

The essence of stopping power is surprise or shock. The photograph contains an unexpected element. This freshness can manifest itself either on the subject level or in the manner of rendition. The best indication that a photograph has stopping power is when other photographers, upon seeing the picture, exclaim jealously: Why didn't I think of that myself?

On the subject level

Stopping power on this level is more easily achieved by professional photographers with their greater opportunity for dealing with exciting subject matter than by amateurs, who in this respect are more restricted. The picture of a famous person will always command more attention than a shot of Jane or John Doe. Professionals also have greater access to wars, floods, famines than Sunday photographers.

On the rendition level

Here however, amateurs have no boss (p. 23) and so are free to do anything they want; thus, they often have an edge over professionals, who normally are more bound by convention. To give the reader an idea of the possibilities open to him, here are some suggestions:

In color photography, transparencies containing a few strong colors boldly displayed are more likely to attract attention than those containing a multitude of different colors in driblets. Sophisticated pastel shades are often more effective than ordinary colors. Black, in contrast to its own darkness, makes adjacent colors appear more luminous. White, in contrast to its own lightness, gives nearby colors added depth. In conjunction, black and white enable a photographer to increase the contrast range of a color rendition without having to pay the penalty in the form of over- or underexposure, since it is impossible to overexpose white or underexpose black. The most powerful color effects are always created by juxtaposition of two complementary colors.

In black-and-white photography, a sure way to attract attention is by means of unusual contrast, by working with pure black and white, preferably in a simple composition. Alternatively, renditions in which contrast is abnormally low, provided they fit the nature of the subject, are more likely to catch the eye than pictures of average contrast. The potentially most effective type of illumination is backlight.

In general photography, unusual means and forms of rendition are more likely to attract the viewer's attention than common ones. This applies particularly to the different forms of perspective and light. Renditions featuring extreme telephoto or wide-angle perspectives are more likely to catch the eye than those in which the subject is rendered in standard perspective. Abnormally contrasty or contrastless forms of illumination, for example, scenes shot in backlight or in the fog, are bound to attract more attention than similar scenes photographed by ordinary light. A closeup makes a more compelling picture than a shot taken from the distance that is average for that subject. Selective focus is often more effective than sharpness throughout the picture. Creative use of film grain (p. 124), halation and flare, unsharpness, blur, and other phenomena normally considered faults can *occasionally* provide the extra touch that turns a plain subject into a good picture. Outdoors, shooting relatively early or late in the day often yields more interesting views than shooting around noon, when the majority of photographs are made.

Unusual composition is an almost infallible means for drawing attention. In this respect, simplicity is never wrong. The fewer the picture elements, the stronger the effect. The ultimate in simplicity are certain photographs by Harry Callahan, some of which show no more than two telephone wires seen against an empty sky, or the dead stalk of a single weed. Print proportions that differ from the standard proportions of four-to-five offer another means for attracting attention. Long, low horizontal formats and tall, skinny vertical ones will always stand out from the vulgar mass of eight-by-tens. And for those photographers who dare to go all out, the abstract techniques of solarization, reticulation, bas-relief, and their combinations, as well as multiple exposure and multiple printing, offer unlimited opportunities for creating eye-stopping effects.

A word of caution, however, is indicated here: No matter what the nature of the device used to draw attention, unless the photographer succeeds in making it an integral part of the photograph, it will not help to make the picture good. Actually, the opposite would be true: Although attracted to the photograph at first, the viewer would soon discover the shallowness of the means that tricked him, would resent having been duped, and reject the picture as phony. Typical misuses of graphically powerful devices are meaningless distortions; multiple images created by shooting through prisms or other trick devices; inappropriate use of colored gels in front of photolamps; overfiltered

126

black skies in black-and-white photography; indiscriminate application of fish-eye lenses; and senseless zooming during time exposures.

GRAPHIC QUALITY

In literature, no matter what the value of the contents of a book, it makes a difference whether the book is written well or badly. In music, although it has no effect on the validity of the score, a poor performance makes the work less enjoyable than a good one. And in photography, the graphic quality of the form in which the subject is presented has a similar influence upon the viewer. High quality can make a picture appear better than it actually is, low quality worse. Therefore, in order to qualify as good, a photograph must not only have something to say, but must also say it well.

The fact that even a cheap camera in the hands of a nitwit will automatically yield pictures that are reasonably sharp and acceptable in color and contrast has led many photographers to believe that any recognizable picture is graphically good. As a result of this complacent attitude, regardless of the nature of the subject or the purpose and meaning of the picture, all their photographs look more or less alike insofar as they give the same average impression. Unfortunately, in photography, average equals mediocre.

A photograph has strong graphic quality if the form of rendition is suited to the nature of the subject, the purpose and meaning of the picture, and the audience for which the photograph is intended. Since the possible combinations are infinite, it should be obvious that no rules for achieving graphic quality can be drawn. In principle, however, it can be said that the simple and strong are preferable to the complex and weak. More specifically, graphic quality is the interplay between the various elements by means of which the image is created —line, outline, and form; sharpness, unsharpness, and blur; light and dark; color, film grain, gray shades, and contrast, each of which can be controlled by the photographer to achieve an optimum effect.

Prerequisite for the production of graphically good photographs are sensitivity and technical acumen on the part of the photographer, on whose decision when to do what rests the success or failure of the picture.

CONCLUSION

A good photograph is analogous to a jigsaw puzzle, where a perfect picture can emerge only if each of its components is in its proper place. A single mistake is bound to ring a sour note; a number of mistakes destroy the picture.

This interrelationship of all the factors involved cannot be overemphasized, because it is the key to good photography. In other words, making a photograph is a step-by-step affair *only* as far as certain technical aspects are concerned—focusing, exposing, developing, printing. In *all* other respects, the photographer must *simultaneously* consider all the different aspects that influence the picture, because a change in one almost invariably necessitates changes in some or all of the others.

VII. How to Make Good Photographs

Essentially, making a photograph presents a problem that must be solved in two respects: in terms of the subject, and in terms of the picture. The first level involves the why and what of photography: Why does a photographer want to make a specific picture? Why does he pick this subject instead of that? What does he want his photograph to say? The second level involves the how of photography: How can a photographer give his vision tangible form?

Both aspects have a common focal point—the photographer—who in turn is subject to three conditions: the devices and techniques of his craft; his own phototechnical and artistic ability; and the audience for which his picture is intended. Consequently, we can say that a good photograph is the result of a successful synthesis of four mutually dependent agents:

**The photographer
The subject
The devices and techniques of photography
The audience**

Here is a brief analysis of these factors—brief, because they have already been discussed extensively in some of my other books, to which the interested reader is referred. (See *The Complete Photographer, Photographic Seeing* (Thames and Hudson 1965, 1974) and *The Creative Photographer,* (Prentice-Hall, Inc. 1955).

THE PHOTOGRAPHER

Every photographer is simultaneously a collector and disseminator, not only of facts, but also of opinions. By choosing to photograph this subject instead of that, he makes a judgment; and if he makes his photographs available to other people, he disseminates what in effect

129

are his personal views. Obviously, the criteria by which he selects his subjects (his facts and ideas), the way he sees reality (his personal point of view), and the form in which he presents his visions (the technical and artistic qualities of his pictures) have an enormous influence on the effect and validity of his work. Therefore, to be able to live up to his responsibility as one who informs and influences people, a photographer must have certain qualifications, the most important ones of which are briefly discussed below.

The ability to see reality in photographic terms

Imagine a photographer on a sunny day on a popular beach trying to capture its splendor in the form of a black-and-white picture. He selects a colorful scene, perhaps a group of children playing a game, and expectantly makes the shot. But when he sees the result, he is dismayed because the picture turned out drab and flat. There is no feeling of depth, color, or life; the figures awkwardly hopping around on one leg or frozen in clumsy positions have little relationship to the boisterous children on the beach. What happened?

What happened was that the photographer ignored the fact that most of the sense impressions that impelled him to take the picture were of a nonvisual nature: the sound of voices and laughter, the salty smell of the sea, the pounding of the surf, the warmth of the sun, and the coolness of the breeze. None of these distinct and pleasurable impressions can be recorded by photographic means. Furthermore, the bustle and motion of life can be indicated in a still picture only in symbolic form (p. 75). The azure of the sky and the red and yellow of the beach gear are changed to shades of somber gray. No wonder that the essence of our photographer's experience was missing in his picture.

In contrast, an experienced photographer would, first of all, have used color film instead of black-and-white to photograph this particular scene—a subject whose most outstanding quality is color. And had he been forced to work in black-and-white, he would have known how to evaluate the subject in these photographic terms: He would have translated the colors into effective shades of light and dark by means of color filters. He might have used contrasty side- or backlight instead of low-contrast frontlight. He could have symbolized motion and created the illusion of life by means of carefully controlled blur. In other words, he would have disregarded all nonvisual factors and known

how to symbolize the visual ones by graphically effective means. This, then, is the secret of photographic seeing:

Disregard all nonvisual sense impressions; then, translate the visual ones freely (p. 80) into photographic terms by means of the appropriate symbols (p. 75).

A valuable aid in learning how to see reality as the camera sees it is a viewing frame. To make one, cut a 4″ × 5″ rectangular opening out of an 8″ × 10″ piece of cardboard. Hold this device in front of one eye, close the other, and study your subject through the opening. This has the following advantages:

1. Looking at the subject with only one eye transforms your normally stereoscopic vision into monocular vision. Instead of being three-dimensional, everything now looks flat, precisely the way a lens would see it. As a result, you will be able to perceive more clearly the presence or absence of photographable symbols of depth, like converging parallels, overlapping of subject elements, foreshortening of form, and diminution.

2. By covering up subject matter outside the area of immediate interest, the frame enables you to see your subject out of context, isolated from its surroundings, as it would appear in picture form. This allows you to evaluate the subject more objectively. Freed from neighboring influences, will it still be interesting enough to make a worthwhile picture?

3. By shifting the frame back and forth, both up and down and sideways, you can determine precisely the most effective boundaries of your future picture. By rotating it 90 degrees, you can also decide whether a horizontal or a vertical format is more appropriate.

4. By holding the frame close to your eye, then farther away, and finally at arm's length, you can find out whether a wide-angle lens, a lens of standard focal length, or a more or less extreme telephoto lens would give you the best result. The closer you hold the frame to the eye, the wider the angle of view and, consequently, the wider the angle of view of the lens that would get you this view; and vice versa.

5. When contemplating the angle shot of a building, by holding the frame at right angles to the axis of sight, you can consciously see the apparent converging of actually parallel vertical lines. This works

because the parallel vertical sides of the viewing frame provide the necessary frame of reference.

Conclusion. Seeing in photographic terms means visualizing possibilities. This is an acquired ability. The photographer who cultivates it can translate reality into picture form in his mind. He can substitute the photographic symbols for depth, color (in black-and-white photography), motion, radiant light, and so on. In other words, what he sees is not so much the subject as it actually is, but as it would appear in his picture. He previsualizes the final effect.

The ability to observe

This requirement may seem self-evident until the photographer remembers how often he has discovered things in his pictures that he had not noticed in reality. The reason for such unexpected discoveries, most of which are harmful to the effect of the picture is, of course, the difference between seeing with the eyes and seeing with the camera: The eyes, under the direction of the brain, are selective, consciously noticing only those aspects of reality in which the person is interested, and paying no attention to the rest. In contrast, the camera, being a machine, sees objectively, noticing and recording on film everything within the angle of view of the lens, the important as well as the superfluous and the aesthetically disastrous. Therefore, the photographer must consciously observe every aspect of the scene before he fixes it irrevocably on film—while there is still time for making changes. This is the only way to guard against unpleasant surprises.

Experience has shown that the more fascinating the subject, the less observant the photographer. Actually, a striking subject seems to exert an almost paralyzing influence upon most photographers, who become so engrossed that they forget everything else. I still remember a session on nude photography at which the students became so hypnotized by the buxom model that they made innumerable pictures which showed not only the girl, but also the blackboard in the background, the lightstands, photolamps, electric wires, the instructor's face or figure, big globs of halation from shooting smack into the lights, fellow students, you name it. The subsequent criticism of the accomplished work understandably left most of the participants with very red faces.

Whereas the tyro pays attention to nothing but the subject proper of his pictures, experienced photographers scrutinize particularly carefully those aspects of a scene which others brush aside as inconsequen-

tial: the background, the foreground, the surroundings, the nature and direction of the light. Outdoors, they watch for unwanted telephone wires and powerlines that cross the sky; wire fences or buildings in the background; bright patches of sky peeking through dark foliage; shadow patterns that might cause an undesirable effect; harsh and ugly shadows on a face, particularly around the eyes and underneath the chin; excessive contrast; unwarranted perspective distortion; strong, eye-catching colors or patches of white in the wrong places. Indoors, they pay particular attention to objects in the background such as pictures hanging on a wall, house plants, ceiling fixtures, and furniture. But they also watch for excessive contrast caused by daylight coming through the windows, reflections in window panes and other glass, such as framed pictures, and unacceptably deep shadows. And they make very sure that their own photolamps, lightstands, and electric wires do not accidentally show up in their pictures.

Furthermore, acute observation is the only basis for timing action shots correctly. Whenever subject motion is involved, appearances change constantly and no two moments are ever exactly alike. Some of these moments, of course, are more significant than others. Only by continuously observing a constantly shifting scene can a photographer capture the most significant instant. This also applies to portraiture: Expressions, poses, gestures change all the time, and to capture those that are relevant and beautiful a photographer must be alert. Other instances where alertness pays off are street scenes, where the pattern of hurrying people and automobile traffic is never the same—now presenting a meaningful configuration, now a shapeless mess. Even landscapes should be watched closely, where drifting clouds form ever-changing patterns in the sky while their shadows make individual hills in the distance either stand out sharply or merge with the rest. It is the observant photographer who consistently brings home better pictures than the unobservant one.

The drive to experiment

Broadly speaking, there are two types of photographers: those who put their faith in instructions and are satisfied to stick to the rules; and those who question everything they read or hear, trust only their own eyes, and experiment.

The purpose of experimentation is twofold: to familiarize the photographer with the tools and techniques of his craft, and to discover new forms of graphic expression. Only he who consciously

133

has photographed in black-and-white a number of colorful objects through all the filters from red to blue knows precisely what each filter can do; and only photographers who repeatedly have shot the same subject from different distances with lenses of different focal lengths know about the subtle differences in perspective that are theirs for the asking, and how to exploit them effectively. And so on.

But going far beyond the value of such photographic finger exercises, necessary as these may be, planned experimentation is the only way to widen one's creative scope. Granted, instructions and rules are indispensable to get beginners off to a good start, avoid disappointment, and guarantee production of recognizable pictures, but they seldom lead to the making of great photographs. Inspired work, no matter whether in photography or any other field, has never been brought about by timid souls who clung to the security of proven rules, endlessly repeating the same old tired clichés. Improvement and growth are tantamount to change, and change requires planned violation of established rules. Without a constant search for new and better forms of expression, photography would remain at a standstill. For these reasons photographers who are ambitious enough to aim for the top, experiment.

The essence of experimentation can be summed up in five words: Let's see what happens if.... However, to prevent meaningful experimentation from degenerating into amateurish dabbling, two rules must be observed implicitly:

1. Never vary more than a single factor at a time in any particular experiment. If more than one variable is involved, the result of the test will be inconclusive and therefore meaningless. For example, when investigating the properties of different brands of color film in regard to color rendition, change only the film, but keep the other factors constant: camera, lens, test object, distance between object and camera, type, direction, and intensity of the light, and so on. And when conducting a color response test with black-and-white film, change only the color filter (and, of course, the shutter speed in accordance with the respective filter factor), but keep all the other factors the same.

2. Take complete and accurate notes on everything you do. If you do not, you cannot repeat the result of the test, and all your work will have been in vain. The best way to insure that notes cannot get lost, or that the different test results are not confused with one another, is to

write all pertinent data on a card, whenever you can. This card is then included in the actual test setup and photographed with it, becoming a permanent part of the record. Remember to make the appropriate changes on these cards every time one of the factors of the test is changed. The time, effort, and money spent on this kind of experimentation is one of the best investments an ambitious photographer can make in his future.

Inspiration, imagination, imitation

"No man is an island" is a deeper truth than most of us realize, and no photographer's work is entirely original. We all learn from one another, are inspired by one another, and imitate one another—to a greater or lesser degree. Even Newton realized that his revolutionary discoveries were partly due to the fact that he had been "standing on the shoulders of giants."

Imitation, psychology tells us, is a crucial part of the learning process. Every baby animal and every child learns by imitating his elders, and the student photographer who imitates the work of his instructor whom he strives to emulate is no exception. This is a perfectly natural aspect of the growth process and nothing to be ashamed of. Eventually, of course, the time comes when the ways of student and teacher must part. The child must learn to stand on his own two feet. And the student photographer, unless he is content to remain a second-rater all his life, must find himself and go his special way according to the nature of his self. He will, of course, continue to look at other photographers' work, to study and analyze it, to learn from and profit by it, but in a more mature manner. No longer will he slavishly copy everything he likes. Instead, he will examine what attracts him, discover the underlying principle, and use it creatively in his own way. When a photographer has reached this stage, the former student has grown up and becomes a photographer in his own right. Imitation has been sublimated and becomes stimulation.

Letting himself be stimulated by another person's work aids a photographer's personal growth. To give an example, utter precision of rendition characterizes the work of Edward Weston. Similarly, extreme simplification is a mark of Harry Callahan's imagery. Now, it is entirely possible that a young photographer, an admirer of both Weston and Callahan, convinced of the creative potential of sharpness and economy of means of expression, would adopt these techniques,

yet use them to create pictures that would be totally unlike those made by Weston or Callahan in subject matter. After all, neither one of these masters has an exclusive on sharpness or simplicity, nor did they invent them. And the applications of these two forms of photographic expression are boundless.

The opposite approach is that of a person whom I consider symptomatic of our time—the organization man, or conformist. In photography, it is he who is responsible for the majority of mindless photographs. He is the joiner, the imitator, the photographer who plays it safe. Such people have surrendered their individuality in exchange for approval, approval by the system, the organization, public opinion, their fellows at the photo club. They have succumbed to fads and trends, they are the in-people who belong to a group or school, and they look down on anybody who does not belong.

In character, such cliques range all the way from ultra-conservative pictorialists to the equivalent of the radical left, but common to all is an intolerant outlook and a tendency to brainwash their members until they think alike. It is this leveling influence which I consider so dangerous—the pressure to conform, to follow the leader, to imitate each other's work and ideas. And this seems true to me no matter whether the disciple belongs to a group whose members have short hair and shave or shoulder-length tresses and beards.

I regard an understanding of the danger posed by any form of group activity as an indispensable prerequisite for artistic growth. Why? Because photographers who identify with special groups where everybody follows the same line of thought are deprived of the stimulating criticism and exchange of controversial ideas necessary for the intellectual and spiritual development of any human being.

Because I believe that exposure to other people's ideas, no matter how farfetched or bizarre, will sooner or later reflect favorably in one's creative work, I have made a habit of collecting visual information that is of interest to me. The principle, of course, is not new, and its physical implementation is variously known as the "swipe file" or the "inspiration box," depending on whether the collector is a copycat or a more sophisticated user of ideas. In my case, the file consists of an 11″ × 14″ photo paper box into which go pictures and articles that I clip from magazines, augmented by occasional Xerox copies of material taken from books.

136

Now, the reader who likes the idea of collecting inspirational material for future use may want to improve my filing system by using a compartmented letter file instead of the primitive catch-all of a box. This idea occurred to me, too, but I discarded it because a high degree of organization, although invaluable for filing material of a technical nature, is detrimental to the efficacy of an inspiration box, whose sole function is to inspire. One simply cannot compartmentalize inspiration, nor hunt for it and expect to find it in a certain place. Inspiration is unpredictable, flashing from the depths of the unconscious mind at odd and often inconvenient moments. It is stimulated by association but cannot be forced. Hence, the deliberate jumble of my inspiration box.

Often, when I am in a relaxed mood, I slowly leaf through the contents of my box, leisurely looking at pictures, letting my thoughts wander, giving my mind free rein. I never know in advance which particular item may hold my attention, nor why it should. But one image leads to another, the stream of ideas begins to flow, new ways of doing things suggest themselves. Some may be useless, some impractical, some good but beyond my means. But then again, a great idea may strike like unexpected lightning, perhaps a new way of seeing things, or a new application of an old technique, or a heretofore neglected subject rich in interest and visual potential. Relaxation, association, and the magic of the inspiration box have done their work.

Photographers less susceptible to visual stimulation must substitute perseverance for imagination. A method that is usually successful is to investigate systematically every controllable factor that contributes to the effect of the picture. How would a given subject look from a different camera position, from higher up or lower down, more from the right or the left or, why not, from the back? (After all, a famous photograph of John F. Kennedy showed the late president looking out the window with his back toward the camera.) How would the subject look in a different light, or in a different scale? In the form of a close-up, or shot with a telephoto lens? Or taken with a wide-angle lens, a panoramic camera, a fish-eye lens? What would be the effect of different kinds of filters—red, yellow, blue, green? Or backlight instead of sidelight, or frontlight, or light from above or below? Sharp all over, partly sharp, or unsharp? Factual or mysterious? Perhaps contrasty and abstracted, stylized, formalized, harsh black and white, or solarized, reticulated, or in bas-relief? The variations and combinations are endless, and sooner or later a conformation is bound to be found that combines significance with freshness of subject presentation.

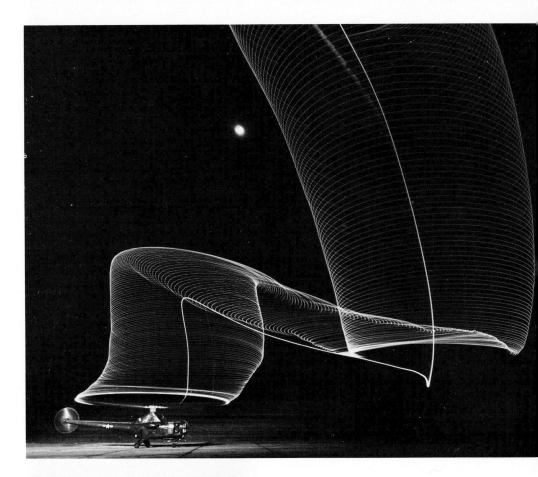

The same subject differently "seen." To improve its visibility during sea-air rescue operations at night, this coast guard helicopter was equipped with lights attached to the tips of its rotor blades. The *Wide World* photograph *at the left* failed to utilize the pictorial potential inherent in the subject. The picture by the author *(above)* is the result of careful planning which even included the position of the moon. Together, they prove that the degree of "perfection" of a photograph is inseparably connected with the way in which the subject is "seen."

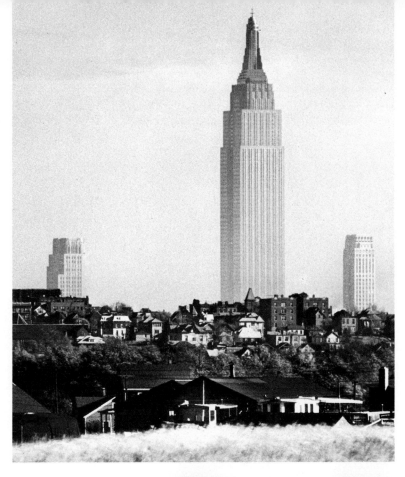

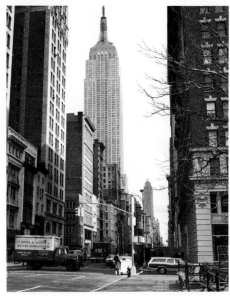

The same subject differently approached. The Empire State Building in New York is one of the world's tallest structures. But photographed from only a few blocks away—*at the right,* as the tourist sees it—it does not seem particularly impressive. To get the full impact of its enormous height, it must be "seen" free from perspective distortion, as in the photograph *above* which, from a distance of several miles, was made by the author with an extreme telephoto lens. Whether or not a photograph is "perfect" is obviously also a matter of subject approach.

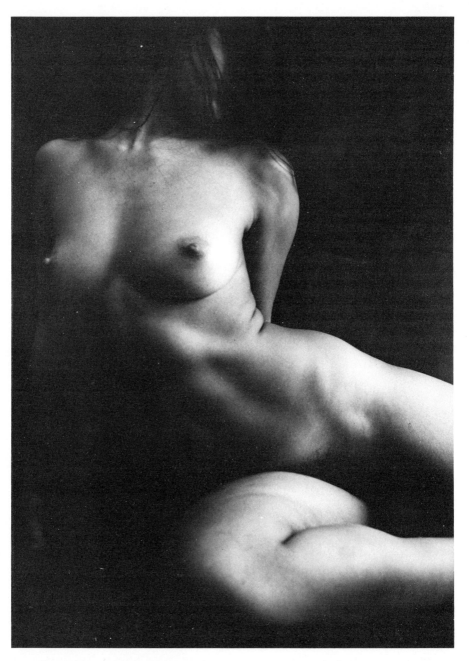

Two photographs by John Veltri which I consider "perfect" because of pose and lighting. The dynamic line flow of the nude reminds me of the sculpture of Maillol; modulation in terms of light and shadow is excellent.

The double portrait of a young Puerto Rican mother and her child is an outstanding example of composition—a double-portrait is not twice but many times as difficult to light and compose as

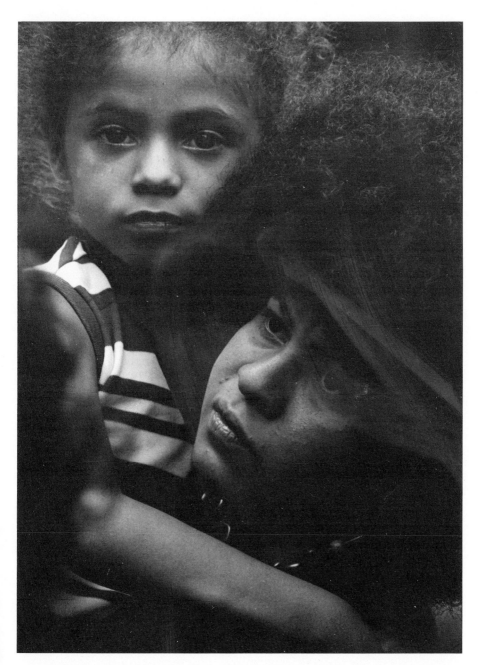

the picture of a single head. And another observation: note how the arm of the child seems to continue the thrust of the left leg of the nude, linking the two pictures into a unit. If their positions were reversed, they would have "fought" one another—a demonstration of the importance of "matching" two photographs that must be shown together. Unless compatible, even the most "perfect" photographs, if displayed together, would be ineffective because they would either "destroy" or neutralize each other.

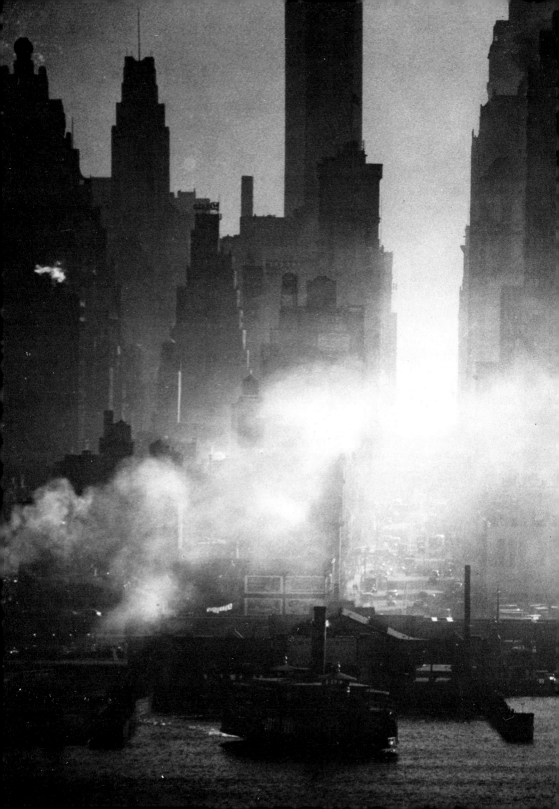

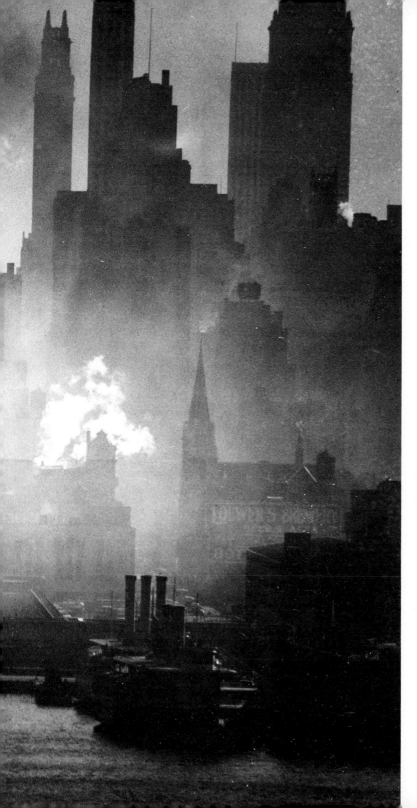

Midtown Manhattan seen across the Hudson, by *Andreas Feininger.* Shot from two miles away on a hazy day, the skyline appeared to the eye as a monochrome in pale blue-gray. On color film, the impression would have been too weak and insipid to do justice to the powerful subject. But photographed on black-and-white film through a deep red filter and subsequently printed on paper of hard gradation, it turned into what I consider a "perfect photograph." This is a clearcut case of black-and-white being superior to color. (See also pp. 91-92.)

Yuccas and **Nude in the sun,** both by Andreas Feininger. A quality common to both pictures is that their gray scale is deliberately restricted to three main shades: white, medium gray, and black—simplicity in photography is one of the most effective means for achieving graphically powerful effects. Note that, in the Yucca photograph, the sky splits the picture into two parts; if black had been solid at the bottom, I would not have made the shot. The feathery edge of

the cloud seems to repeat the dagger forms of the leaves—a rounded cloud edge would have been less effective. In the nude, the feeling of simplicity is further heightened by placing the figure against the sky, a background which is neutral yet not "dead" like, for example, an evenly illuminated sheet of seamless photographic paper. The natural squint, the sandy elbow, and strong shadows unmistakably spell sunshine at the sea.

Self-portrait, by *Angus McBean.* Four separate exposures, each complementing the others so that the result is a triple-view of the head, were combined to make this composite portrait which brings to mind certain works by Picasso. The result is so convincing that I feel I could recognize this man should I meet him in the street—despite his two noses and three eyes.

The actress Beatrice Lilley, by *Angus McBean.* The surrealistic approach suggests the world of the theatre and make-believe. This is one of those imaginative photographs which are not "obvious"—they require time and thought on the part of the viewer: why the sand and the glass bell, why those pointed shards? What did the photographer have in mind when he made this picture?

Phototechnical ability

It may seem axiomatic that a photographer must be able to handle a camera expertly and know how to develop and print. As a matter of fact, most people would probably consider these skills indispensable prerequisites for making effective photographs. In my opinion, this is only partly true, for the following reasons:

As I have explained repeatedly in different connections, the value of a photograph lies above all in its message. If its contents are stimulating, well seen, and presented in an imaginative form, a picture has value; if it is dull or trite, it is a waste. Not even a phototechnically perfect rendition can change this. Nothing, beautifully packaged, still adds up to nothing. In other words, perceptiveness, sensitivity, and imagination on the part of the photographer are what count, with the work of the technician taking second place.

This view has been fully confirmed by what I observed during my twenty years as a staff photographer for *Life.* Quite a few of my colleagues who unanimously were considered past masters in their craft had only the sketchiest ideas about phototechniques, were incapable of developing a roll of film, and wouldn't dream of making a print. They were unsurpassed when it came to handling a camera and seeing picture possibilities, but they had only the vaguest ideas of how the picture came about.

Conversely, I have known photographers who not only owned the finest equipment but literally were in love with it, who were walking encyclopedias of phototechnical information, who were wizards in the darkroom, whose grainless prints sparkled, but who had never been able to make a worthwhile picture.

What I want to get across is this: Important as phototechnical ability may be, it is only a means to an end—the realization of a vision. Don't get me wrong—I'm not knocking good technique, nor is this a case of sour grapes. As a matter of fact, I consider myself a first-rate darkroom man who can compete with the best. But I feel strongly about values in photography and want to make sure that the reader sees things in their proper proportions: vision first, technique second. I have encountered too many cases where potentially good photographers were ruined by putting emphasis in the wrong place, on phototechnique. They spent so much time and interest on honing their technical skills that they had no time for learning how to see. As a

148

result, their sparkling, grainless photographs were academic and boring, their color slides trite.

Another undesirable consequence resulting from overemphasis on technical acumen is the fact that it can inhibit a photographer. Strange as it may sound, knowing too much often seems to put a damper on spontaneity and daring: Knowing the precise contrast range of his film can prevent a photographer from taking certain risks, such as shooting by backlight, shooting by fading evening light, grabbing a shot when there is no time to take a light meter reading, and so on. In other words, rather than daring to take a technically uncertain shot and possibly wasting a frame of film, photographers who are knowledgeable enough to calculate their chances frequently abstain from making the photograph. And by this cautious attitude, they often rob themselves of what conceivably might have been a sensational picture.

To these photographers I say: Honestly, what do you have to lose except a single frame of film? Have you never heard of serendipity? Why not go ahead and make that questionable shot, the picture that might make you famous? Make hand-held pictures with long telephoto lenses regardless of the danger of camera shake (steady the lens barrel against a solid object); shoot right against the light and never mind the danger of flare (potentially the strongest symbol of radiance); make that grab shot (a slight degree of blur or underexposure may actually enhance the picture); and never mind the fact that the incident daylight is not always standard (the resulting color shift may turn a so-so scene into a marvelous picture). Loose your inhibitions, forget about the rules, remember that there are situations where it is advisable to shoot first, and ask questions afterwards. Film is the cheapest and most expendable commodity of a photographer, but a chance is unique.

THE SUBJECT

Today, thanks to the enormous scope of modern phototechnology, there is no subject that cannot be photographed. And thanks to the perfection of the 35mm single-lens-reflex camera and its accessories, there is no subject that cannot be photographed with this particular instrument. Why, then, this special chapter on the subject?

Photographic subjects vary enormously in their nature—from gems to girls to galaxies. Because of these differences, some subjects require certain ways and means of rendition, for most effective presentation, while other subjects require others. An analytical examination of the subject can therefore aid a photographer in his selection of the most suitable devices and techniques of presentation. This, in turn, is bound to reflect favorably on the quality of his work.

No two subjects are ever exactly alike. Some have certain qualities that others lack, and some of these qualities are more effective in photographic rendition than others. Accordingly, selecting his subject whenever he can on the basis of such photogenic qualities provides the photographer with another way to improve his standards.

From the photographer's point of view, subjects can be classified in seven groups. Here is a brief run-down of these groups and their characteristics as I see it:

Photographic and literary subjects

Inherently photographic subjects are visually interesting; literary subjects can best be described by words. The first are basically suited to photography, the latter are not, since a pictorial rendition would be unable to do them justice. A face, for example, is a typically photographic subject, a war memorial a typically literary subject. No verbal description of a face can be as authoritative, significant, unambiguous, and complete as a photograph. But no photograph of a war monument can adequately explain the meaning of the depicted subject whereas a word picture can.

Making a distinction between photographic and literal subjects was particularly helpful to me in my work at *Life*. The first type usually presented no specific problems; but to make a picture out of the second kind often taxed my imaginative resources to the limit. In this kind of assignment, the subject is only a symbol for something else, say, a famous man who had been born in a particular house that I had to photograph, or a battle won or lost symbolized by the hackneyed statue of some general on a horse. To make an interesting and informative picture out of something as unprepossessing as a house or statue requires imagination, daring, and luck—a blood-red sunset sky, black thunder clouds and bolts of lightning, driving rain or snow, mist rising at dawn, a crazy angle, the violence of distortion, flare and

150

halation symbolizing glaring light. Something extra is needed to give the symbol life, for rendered as a literal translation (p. 80), a literary subject will yield a picture that is dead.

Photogenic and unphotogenic subjects

Photographic subjects can be divided into two major groups: visually attractive subjects, likely to be effective in photographic form; and subjects that, no matter how important or interesting they may be in other respects, are visually uninteresting, dowdy, or confusing, and therefore unlikely to be effective in picture form. Among photographers, the first kind is known as *photogenic* and, needless to say, preferred, while the second type is *unphotogenic* and shunned. For me, I have found that the following qualities tend to make a subject photogenic:

Simplicity, manifested as boldness of outline and form. In color photography, a few strong colors boldly displayed are more effective than all the colors of the rainbow scattered throughout the picture. In black-and-white photography, high contrast graphically simplifies a picture to a higher degree than normal contrast and, provided it does not conflict with the purpose and meaning of the photograph, is one of the most effective means of rendition.

Order and clarity of organization contribute to understanding and have a greater eye appeal than disorder and overcrowding, which promote confusion and eye fatigue.

Contrast. In black-and-white photography, subjects of abnormally high contrast, *e.g.*, backlighted scenes, and abnormally low contrast *e.g.*, pictures shot in the rain, in fog, or during a heavy snowfall, usually have greater eye appeal than subjects of normal contrast, which make a more ordinary impression. In color photography, inclusion of pure blacks and whites enables a photographer to greatly expand the contrast range of his rendition without having to pay the penalty of overexposure of the lightest colors and underexposure of the darkest, since it is impossible to overexpose white and underexpose black.

Color. In black-and-white photography, strong coloration is basically an unphotogenic subject quality; such subjects should be taken on color film. If strong-colored subjects have to be photographed in black-and-white, color contrast must be translated into black-and-

white contrast by means of proper filtration. In color photography, unusual colors have greater eye appeal than ordinary ones. In this respect, *unusual* means either very strong and saturated colors, or very soft and pastel colors. Thus, red sunset skies are more unusual than blue skies at noon; a face seen in the golden glow of early morning light is more unusual than when seen in standard daylight. Pure blacks and whites are, in my opinion, perhaps the most important colors of the color photographer, not only for the reasons stated above, under "Contrast," but also because black, in contrast to its own darkness, makes adjacent colors appear more luminous, while white, in contrast to its own brightness, gives adjacent colors added depth.

Spontaneity enlivens a picture and is one of the most desirable subject qualities. To capture it in picture form requires sensitivity and alertness on the part of the photographer. When photographing live models, for example, the surest way to kill spontaneity is to use the popular command "say cheese." Overdirection weakens spontaneity, posing destroys it.

Animation and motion are basically photogenic subject qualities. Conversely, inanimate subjects and subjects at a standstill normally make less appealing pictures. To be effective, however, movement must be freely translated into picture form (pp. 58 and 77), since, if frozen, the subject will appear to be at a standstill, and the illusion of motion will be destroyed.

Pattern, rhythm, and repetition of identical or similar forms can give a picture a high degree of order and organization and are therefore photogenic subject characteristics. Care must be taken, however, to integrate these qualities in a meaningful way into the composition of the picture. Used merely for their own sake, the effect easily appears contrived and the photograph pointless.

Surface texture, provided it is clearly defined through sharpness in conjunction with contrasty, low-skimming light, gives identity to a subject. It says, this is sand, this is stone, this is wood, this is fabric. Since it increases the informative value of a picture and also makes it graphically more attractive, texture is a photogenic quality. Conversely, unsharp rendition of a textured surface, by leaving the viewer guessing the nature of the depicted substance, is normally unphotogenic.

Telephoto lenses, because they force the photographer to keep relatively far away from his subject, show objects in different planes in

more natural proportions relative to one another, and generally produce a more interesting form of perspective than lenses of shorter focal length. They are, in my opinion, more conducive to photogenic rendition than standard or wide-angle lenses.

Closeups, because they show the subject in more concentrated form and larger scale with more detail, normally represent a more photogenic form of presentation than views taken from greater subject distances.

Backlight, in my opinion, is a more photogenic type of illumination than light from any other direction.

Unphotogenic, and therefore to be avoided, are the following qualities, techniques, and practices:

Insipidity—lack of subject interest—is the most common reason why a picture fails to hold the viewer's attention. The only remedy is more discrimination, self-discipline, and awareness on the part of the photographer.

Excessive complexity is another common photographic fault. It is a consequence of the fact that the camera sees everything within its scope, whereas the eye notices only what the photographer considers important. Excessively complex pictures are confusing and visually unattractive but are easily avoided if the photographer closes in on the subject, works with a lens of a longer than standard focal length, focuses selectively, or eliminates superfluous subject matter by other means in the picture.

Lack of organization of subject matter can turn even a photogenic subject into an unattractive picture. Organization—composition—is a vitally important aspect of picturemaking that should permeate the entire thinking of a photographer from the moment he conceives the idea for a picture until he finishes the slide or print. Readers interested in this very important subject are referred to my book *Principles of Composition in Photography* (Thames and Hudson, 1973).

An unsuitable background or foreground is another factor that can ruin what otherwise might have been an attractive picture. More on this on pp. 159–161.

153

Ugly shadows can spoil the effect of any picture. Unless it is part of the concept, the shadow of the photographer should not appear in the picture; likewise, unless it contributes to the composition, the shadow of the subject must not fall on the background. In portraiture, the shadow of the nose must never cross or even come close to the lips, and deep shadows around the eyes, underneath the chin, or cast by a hat should normally be avoided. Shadows within shadows, cast by the main light and the fill-in light, and shadows that criss-cross one another in different directions, if two or more lamps are used simultaneously, are amateurish, confusing, and ugly. A good photograph, regardless of the number of lamps actually used, never shows more than a single set of shadows.

Excessive shadow fill-in is a common unphotogenic phenomenon. In my opinion, when in doubt, too little fill-in illumination is preferable to too much, because the latter destroys the illusion of depth, eliminates contrast instead of only reducing it, and creates unnatural effects.

Excessive distance between subject and camera is another common mistake. The subject is often rendered in a scale too small to be effective, and superfluous matter surrounding it weakens the impression of the picture.

Single flash at the camera, used all alone by itself, is, in my opinion, the most unphotogenic type of light.

Posing and faking, for reasons explained before (p. 63) are, needless to say, thoroughly unphotogenic practices.

Gimmickery—originality for originality's sake—is an unphotogenic substitute for imagination, a cheap way to catch the eye of the viewer, a façade with nothing behind it. Gimmicky photographs will attract attention at first, but will soon be recognized for what they are and be rejected as phony. Typical examples are pictures shot through prisms and exposure meter grids, indiscriminate use of colored gels in front of photolamps, and unwarranted distortions. It goes without saying that discriminate photographers reject such means.

Tangible and intangible subjects

People and objects are tangible, feelings and moods intangible. The first can be photographed, the second cannot. But intangible things can

be symbolized. Consider an ordinary passport photograph: a deadpan face staring at an automatic camera, no trace of feeling evident in its expression. Then think of an animated snapshot of this person, perhaps a mother with her baby, a father with his son, the face alive, the eyes alert, smiling, radiant with happiness and love, or intense and concerned, expressing feelings. There you have pictures of intangibles, feelings symbolized by a smile, a frown, a gesture.

Again and again we find that it is the presence or absence of such intangibles that makes the difference between a good photograph and a nondescript one. I discussed earlier the difficulty of adequately photographing inherently literary subjects. Shown in the form of a straight documentary photograph, the picture of the famous man's birthplace and the war memorial have all the charm of a deadpan passport shot, because they cannot make the viewer feel anything. But photographed in the dawn's early light, tinged with rose and gold, the famous man's birthplace can acquire an aura of hope and future, pointing to his later work and accomplishments; and shot under a dark and thunderous sky, the war memorial can be made to look ominous and brooding, the gloom of the picture symbolizing the sorrow and agony and futility of war. Imagination and careful selection of the appropriate conditions under which the photographer makes the picture can combine to express symbolically what he felt in the presence of his subject.

The importance of the role that mood and feelings play in photography is apparent in any photograph. If it doesn't make the viewer feel something, it is nothing more than a record shot. Now, record shots are, of course, vitally important to the proper functioning of our society; but this is not what I am discussing here when I talk about good or ineffective pictures. To be effective and good, every photograph of the kind this book is concerned with must convey feeling.

Take, for example, photographs of nudes. No matter what aesthetes, puritans, or representatives of women's lib may say, a view of the nude female body inevitably turns the viewer's thoughts to sex. This is what he expects from such pictures, this is why photographers make them, this is as normal and natural as sunrise at dawn, and anybody who thinks otherwise, in my opinion, needs a psychiatrist. Now, some photographers of nudes are still so much under the influence of Victorian ideas of propriety or so inhibited that they carefully avoid in

their pictures any hint of sensuality, which their warped minds equate with lewdness. The result, of course, are photographs so stilted and arty-pretentious that they make normal people laugh. This, of course, does not mean that a nude picture has to be pornographic to be good. A good nude neither makes the viewer want to laugh nor does it disgust him. But if he feels admiration accompanied by a sudden surge of desire, the picture is good, for its real subject is not the female body but sensuality, an intangible, a feeling, a state of mind.

That similar considerations apply not only to what sometimes are called artistic photographs but to everyday pictures as well should be clear if we think, for example, of advertising photography. There, the value of a picture depends not only on the factual accuracy of the representation, but to an even higher degree on the emotions it evokes in the viewer. If it can convey feelings of luxury, power, dependability, safety, or other desirable intangible qualities and thereby induce a prospective customer to buy the advertised product, the picture is successful and good; without these intangibles it is worthless.

> **Good photographs are pictures of tangible subjects enhanced by intangibles—feelings and mood—expressed by means of symbols.**

Static and dynamic subjects

Landscapes and buildings are static subjects, people are dynamic. What is the purpose of making this distinction? It has to do with subject approach, subject rendition, and phototechnical demands. Here is how I see things:

Static subjects are motionless. They hold still. The implications are twofold: The photographer can take all the time he needs to study his subject and find the most effective approach; and he can make the photograph with a camera of relatively large size, which will yield pictures of potentially higher graphic quality than a small-format camera. The disadvantages connected with large-camera photography— primarily conspicuousness and slow speed of operation—are normally no obstacle in photographing static subjects, but they make large cameras unsuitable for photographing dynamic subjects.

The clue to successful photography of static subjects is *contemplation.* Don't hurry. The subject cannot run away. You have all the time

156

in the world. Take advantage of this by studying your subjects from different viewpoints—literally as well as figuratively speaking—and under different conditions, if necessary, coming back another time for a second look, or a third, or a fourth. Then you can make the picture with the largest film size practical.

Dynamic subjects are in constant change and motion. Here, too, the implications are twofold: The subject never looks exactly the same twice—once an opportunity is missed, it is lost forever; and the photographer must use a small, fast, and inconspicuous camera with a large film magazine, since he may have to take a large number of shots in rapid succession to be sure not to miss a significant moment. The disadvantage of small-camera photography—somewhat lower graphic quality than that of pictures made on film of larger size—is the price a photographer has to pay for inconspicuousness, mobility, and high-speed operation.

The clue to successful photography of dynamic subjects is *preparedness.* The photographer should be prepared mentally by being observant and alert, knowing what to expect and when it might happen. He must be quick on the trigger when he believes the moment for action has arrived. Shooting too many pictures is better than shooting too few; trying to save on film is disastrous. And he should be prepared phototechnically by setting his camera controls in advance and prefocusing the lens as far as practicable, so that at the proper moment he only has to raise the camera, aim, and shoot.

Subjects for black-and-white and for color

Since I discussed this problem before (p. 84), I need to recapitulate here only briefly. Although exceptions exist, some types of subject are most effective when photographed in black-and-white, others in color. The decisive criteria are contrast and color. If contrast is high, and particularly if color is relatively unimportant, a black-and-white rendition is normally most effective. Conversely, if color is the most important subject quality, a rendition in color will generally produce the best result, particularly if subject contrast is low.

Most photographers seem to believe that a color photograph is *ipso facto* better than one in black-and-white. That this is a fallacy is proven convincingly by the work of world-famous photographers like Ansel Adams, Wynn Bullock, and Harry Callahan, who prefer to make their photographs in black-and-white (see also pp. 91–92). Likewise, the notion that a photographer can render any subject under otherwise

identical conditions either in color or in black-and-white and get equally good results in both cases is erroneous, for reasons explained before (pp. 84–85).

Frequently, the question whether a photographer is confronted by a subject suitable for black-and-white or for color amounts to one of probability: Which is more likely, a good rendition in color, or a good rendition in black-and-white? Take an outdoor portrait, for example. The weather is dubious, the sky overcast. Under those conditions, is it more likely that the transparency would look natural, or that it would have a color cast? (Remember, in portraiture, any good black-and-white rendition makes a more natural impression than a color shot in which the skin tones are bluish, greenish, purplish, too yellow, or too red.) If the light is of an uncertain color, as in this situation, and the photographer is striving for a conventional portrait, my advice is to shoot in black-and-white, because this technique is more likely to produce a good picture.

And then there is the problem of controllability. A black-and-white rendition can be controlled to almost any extent, a color picture on reversal film cannot. In a color transparency, for example, a certain red is either true or false, *i.e.* unnatural. But in black-and-white photography where red is nothing but a shade of gray, this same red, by means of filtration, can be transformed into any desired shade of gray, including white and black. Since this difference directly affects the contrast range of the rendition, which in turn affects not only the graphic quality, but also the ultimate impression of the picture, it can become a decisive factor in the photographer's decision whether to shoot a specific subject in color or in black-and-white.

Primary and secondary subjects

Most photographers recognize only one type of subject—the subject, the object of their interest, whatever this may be. They forget that, unless the subject proper fills the entire frame of the picture, most photographs consist of several clearly defined picture elements: the subject, the background, and the foreground. They overlook the fact that the most effective treatment of a subject comes to nought if an objectionable background or foreground spoils the picture. Experienced photographers therefore give as much attention to seemingly secondary subjects as they give to the primary one. Specifically, they consider the following:

158

The background. For practical purposes, it is advisable to distinguish among four different kinds of background: suitable, objectionable, neutral, and integrated. Here is a brief analysis of each:

A *suitable background* is one that quietly completes the subject. In black-and-white photography, in order to avoid an ugly merger of subject and background, it is light where the subject is dark, and dark where the subject is light. In color photography, it differs sufficiently in hue or shade from the subject to permit the latter to stand out distinctly. In every case, it is unobtrusive and subdued in shade of gray, color, design, and subject matter so as not to compete with the main subject of the picture. A background deliberately kept unsharp by means of selective focus is generally more suitable than one that is rendered sharp.

An *objectionable background* is one that conflicts with the subject or draws attention away from it. A background is normally unsuitable if it is similar in gray shade or color to the subject or, worse, identical; if it is too obtrusive, because of aggressive color or design; if it is in bad taste, because of loud and vulgar color; if it contains confusing, distracting, or ugly subject matter, such as utility wires crossing the sky or a tree that appears to grow out of the lovely model's head; and if it is abnormally dark, *i.e.*, underexposed, a common fault of many indoor photographs, where illumination often consists of only a single flash on camera.

A *neutral background* is one that is completely uniform. Common examples of this type of background are uniformly colored cardboards, seamless paper, a whitewashed wall, a lighttable (for shadowless rendition of small objects), and a clear blue or evenly overcast sky. Neutral backgrounds can be enormously effective where clarity and simplicity of rendition are paramount or if the subject proper is relatively complex. If the background is rather close to the subject, care must be taken not to destroy its uniformity by letting any shadows fall on it accidentally. This can be avoided either by increasing the distance between subject and background, or by relocating the photolamps.

An *integrated background* is one that forms part of the subject proper of the picture. For example, in the shot of a life class at work, the model in the background would have to be considered subject proper just as much as the students with their easels in the foreground; and in the photograph of a turnpike construction site, the men and

machinery in the foreground would be no less important for the effect of the picture than the distant skyline of the city to which the highway leads. In cases in which the subject proper, the foreground, and the background are integrated, a rendition that treats these elements with equal emphasis—that is, sharpness throughout the picture—normally produces the most appealing results.

The foreground. For practical purposes, it is advisable to distinguish among three different kinds of foreground: foreground that is a continuation of the subject in the direction of the camera (for example, the foreground in a landscape photograph); foreground matter in front of the subject (for example, branches or leaves through which the subject is seen); and foreground matter that surrounds the subject in the form of a frame (for example, an archway acting as a frame through which a distant subject is seen). Properly used, each of these types of foreground can enhance the value of a photograph; misused, they can destroy it.

Foreground that is a continuation of the subject toward the camera symbolizes nearness and earthly qualities. These feelings are evoked more strongly the closer the front edge of the foreground in the picture and the wider the angle of view of the lens used. For best effect, sharpness of rendition throughout the entire picture is normally required.

Foreground matter in front of the subject, either in the form of individual objects or as a grill-like or screenlike affair (for example, the bars of a cage, wrought-iron scrollwork, a loose curtain of leaves or hanging branches), if deliberately rendered unsharp by means of selective focus, constitutes a powerful symbol of depth. This can therefore give the picture a pronounced three-dimensional effect. If rendered sharply, however, such foreground matter would blend with the subject or might even become the subject of the picture, at least as far as the viewer is concerned. Either way, the result would probably be confusing.

Foreground matter that frames the subject—an archway, a window, a couple of trees, branches leaving an opening through which the subject is seen—offers a photographer an opportunity to consolidate his composition. For best effect, this kind of foreground should usually be rendered sharp and very dark or black. In that form, it acts not only as a frame for the subject, but also, through contrast of dark (foreground)

160

and light (subject), aids in creating the illusion of depth. Why? Because aerial perspective makes objects appear increasingly lighter with distance, we subconsciously equate darkness with nearness and lightness with distance and experience the juxtaposition of light and dark as depth.

The sky is a secondary subject that most photographers neglect, although it fulfills an important purpose: It sets the picture's mood. A cheerful summer sky—white fluffy clouds drifting on an ocean of blue —obviously evokes feelings that are different from those induced by a dark and thunderous sky, or an evenly overcast sky, or an endless expanse of unrelieved blue, or a flaming sunset sky, or a rainy, stormy, hazy, or windswept sky. An interesting and significant sky, by reinforcing the character of the subject, can sometimes make a picture; the wrong type of sky can break it. Sometimes, as already mentioned in the discussion of the literary subjects (p. 150), finding the suitable type of sky can elevate what would otherwise have been an ordinary record shot to the state of a *picture.* And at all times, a photographer can control the gray shade or color of clouds and sky within considerable limits with the aid of filters or a polarizer.

The horizon, if present in a photograph, affects the picture in several ways: a high horizon, by devoting most of the picture to the ground, emphasizes nearness and elicits feelings of earthiness, security, and intimacy. Conversely, a low horizon, by giving most of the picture space to the sky, emphasizes remoteness, creates a sense of freedom, and evokes more spiritual feelings. The first makes the scene appear massive and heavy, the second airy and light.

A horizon dividing a photograph into equal parts creates impressions of monotony, equilibrium, and rest, which may or may not be desirable (see also p. 17). A level horizon—the sea, the plains— should usually be level in the photograph, too; otherwise, the picture looks sloppy. A straight and horizontal horizon symbolizes static qualities—equilibrium, serenity, security, permanence. A tilted horizon gives the picture a dynamic feeling and suggests instability, action, motion, and change. A wavy horizon suggests fluidity and gentle change; a jagged or strongly vertical horizon, like the skyline of a mountain range or a city, evokes feelings of action, conflict, and drama.

Accessories and props are secondary subjects that photographers use to enhance the effect of their pictures. They range all the way from cigarettes or pipes, which allegedly help the model to relax during a

portrait session, to the telephones of pin-up girls and the toys intended to keep children busy and in the plane of focus. Other props are costume jewelry, colorful scarves, flowers, house plants, cats and dogs. The care and sensitivity with which a photographer selects these secondary subjects, which may figure prominently in the picture, in terms of appropriateness and color have a decisive influence on whether or not his photographs will be good. The wrong kind of accessory can cheapen and vulgarize a picture; a well-chosen prop can improve it.

The hands-off subjects and photographic clichés

In this category belong all those subjects that have been photographed to death. Since I list the most common ones on p. 121, and since any aware photographer can doubtless think of many others himself, I want here only to draw the reader's attention to the fact that not every photogenic subject will make a worthwhile picture. For the truth is that all photographic clichés are photogenic. That is why they are so popular. However, even the most photogenic subject becomes a drag if it is seen too often. Hence, my advice: Hands off. This warning also applies to most subjects that are "picturesque," and still more to quaint and cute ones, which I consider photographic poison.

THE DEVICES AND TECHNIQUES OF PHOTOGRAPHY

Insight must be transformed into performance, and photographic equipment and techniques are the indispensable *means* by which photographers translate their visions into picture form. To make this process effective, the tool must suit the task. Therefore, in my opinion, *suitability* is the number one requirement that photographic equipment and techniques must meet.

This fact, however, is not recognized universally. Again and again I hear photographers complain: If only I had a better camera—a Leicaflex, a Nikon, a Hasselblad, a Linhof—I, too, could make great photographs. This, gentlemen, I don't believe. If a photographer is unable to make good pictures with an inexpensive camera, he will do no better with a thousand-dollar instrument. For it is not the price tag of the tool that decides the value of the picture, but the photographer's talent and skill and the suitability of his means.

162

The camera may be a wonderful instrument, but what it cannot do is selective thinking. In itself, a camera is no more creative than a lump of clay. But like a lump of clay, in inspired hands, it becomes a means of creation. The photographer is the creator. It is he who gives a camera life and makes it work, reflect his personality, express his ideas, give tangible form to his visions.

The point, then, is *not* whether a camera is, say, a Leicaflex or a Linhof, but whether or not it is *suitable* to the task ahead: whether it is a 35mm single-lens reflex or a 4″ × 5″ view camera; whether or not it is equipped with swings for perspective control; if it is to be used for close-up photography, whether or not it is free of parallax and equipped with the means for rear-focusing; and so on. In other words, in terms of pictures, brand name and fame mean nothing, design is everything. Similarly, it does not matter whether a color filter bears a famous name but whether it is red, yellow, or blue. Nor does it matter who made a photolamp or what it costs, but it matters enormously whether or not its color temperature is compatible with the color film it is used with and whether it delivers continuous or discontinuous light; and so on.

What I want to say is that a budget that prevents a photographer from buying the products of famous equipment-makers is no excuse for sloppy or uninspired work. Great pictures have been made with inexpensive cameras, and a thousand-dollar price tag does not guarantee a thousand-dollar picture. This is a fact. I hope it will give new confidence to those photographers who, because of limited circumstances, cannot afford the equipment of their dreams and see this handicap as a crippling brake on their work.

Now the reader may rightfully ask, Why do professional photographers always buy the most expensive equipment if cheaper stuff allegedly does just as well? The answer is that expensive cameras are better made than cheap ones. They are more reliable and stand up better under heavy use, and their scope is augmented by a greater variety of more specialized accessories. Average photographers, however, don't really need this extra strength and precision, nor will they normally have use for most of the specialized accessories. Furthermore, the difference in sharpness of pictures taken with inexpensive and thousand-dollar cameras, provided it exists at all, is negligible, whereas, inexpertly handled, even the costliest camera will produce fuzzy negatives and under- or overexposed slides.

If I deal here with the phototechnical aspects of picturemaking only briefly, it is for two reasons:

1. Although every good photograph is a successful synthesis of technique and art, the role that art plays is ever so much more important than that of technique. It is also less well understood by the majority of photographers and more difficult to explain. Hence, the disproportionately large amount of space devoted to art in this book.

2. In contrast to art in photography, technique is easy because it is specific. It is governed by rules that can be taught. Any number of books are available to anybody who wants to make the effort to learn how to expose, develop, and print. Specific instructions are therefore not required here.

What is important, however, is that the reader see things in their proper perspective: Vision and art come first, technique second. Worry about developing your camera eye, your ability to see in photographic terms, your involvement in the subject, but not your phototechnical skills, because these will come automatically and will improve with practice.

THE AUDIENCE

Since photography as I see it is a means of communication, each photograph is addressed to a more or less specific audience. Now, to be effective, a prime condition for success is, of course, that the picture is understood as well as appreciated by those for whom it is intended. Consequently, when planning his photography, a photographer must always keep in mind the final use of his pictures.

What I mean by this is perhaps best illustrated by an analogy: Nobody in his right mind would have given, say, Picasso the job of illustrating a Sears Roebuck catalogue, nor would anybody ask Norman Rockwell to make the drawings for a sophisticated fashion magazine. In other words, the approach to a particular photographic problem must take into account the purpose and final use of the picture. In this respect, it has been my experience that three principal fields of photographic use can be distinguished:

Utilitarian
Documentary and illustrative
Creative and interpretive

164

Utilitarian photography

It usually plays the role of a handmaiden to some other profession or business. Typical examples are scientific and catalogue photographs, photomicrographs, aerial photographs, and medical and X-ray photographs. Their purpose is to record facts for immediate or future use and reference. The ideal is the perfect reproduction. Its value is directly proportional to the amount of information it contains and the clarity with which this information is presented. Sharpness, contrast, a high degree of subject organization, evenness of illumination, which avoids harsh or extensive shadows, and a neutral background are normally prerequisites for success. Imagination is a hindrance rather than an asset, although a great amount of technical talent is sometimes required to fully exploit the often highly sophisticated devices used for record-making.

Documentary and illustrative photography

It is perhaps best characterized by Webster's definition of the term *documentary*: "Recording or depicting in artistic form a factual and authoritative presentation as of an event or a social or cultural phenomenon." This is an admirable statement of the essence of any documentary, illustrative photograph whose subject and message are factual, while the form in which they are presented is artistic.

The primary purpose of documentary and illustrative photographs is to inform and educate. Excellent examples of this type of photography can be found in the now-defunct great picture magazines *Life* and *Look* and the still flourishing *Paris-Match*. It is also the form of photography I have tried to employ not only in my former work for *Life*, but also in my picture books, particularly in *Shells* (1972), *Trees* (1968), *Forms of Nature and Life* (1966), *Maids, Madonnas and Witches* (1961), and *New York* (1964). A factual subject approach, clarity of concept and organization, originality of seeing, and a graphically interesting form of presentation are prerequisites for success.

Creative and interpretive photography

It is a form of art, its purpose to enrich and stimulate the mind of the beholder. In its highest form it is a means of self-expression, offering creative people an opportunity to share their outlook and findings with others. Again, an analogy suggests itself: If documentary

165

photographers can be compared to journalists, biographers, and factual writers, then creative photographers are the counterpart of writers of fiction and poets.

Whereas facts are the province of documentary photography, feelings are the domain of the interpretive photographer. Curiosity, originality, and imagination are essential qualities for success, but a complete command of the technical potential of the medium is also needed, since this kind of photography often requires extremely complex means for its realization. An outstanding example of creative photography is, in my opinion, Sam Haskins's imagery, as exemplified in his books *African Image* and *November Girl*. Photographs of this kind appeal particularly to sophisticated audiences, who expect from good photographs as much information, stimulation, and food for thought as from good books.

Other considerations

Additional considerations that come under the heading *audience* have to do with practical problems. Very complex photographs need a certain minimum size to be effective. If chosen for reproduction in small scale, their effect would be lost. On the other hand, photographs consisting mainly of simple forms can tolerate considerable reduction in scale and still look good. Pictures chosen for newspaper reproduction must take into account the coarseness of the dot screen and the low quality of the printing. Thus, they should be simple and clear and have higher than average contrast.

Then there is the matter of overkill—putting an unnecessary amount of effort into making a photograph, an effort that is not reflected in the final appearance of the picture. Keeping this in mind and encouraged by previous experience, I made all the color photographs for my book *Shells* on 120 rollfilm. Yet in the book, these pictures appear every bit as sharp and detailed as the reproductions in a competing work, the originals of which consisted of 4″ × 5″ and 5″ × 7″ transparencies. In this case, the degrading effect of the engraver's screen wiped out the advantage of the larger film size, which had been gained at considerable cost in effort, money, and time.

166

VIII. Summary and Conclusions

I am very much aware of the fact that the statements made in this book represent the personal experience, opinions, and conclusions of only one man, myself. I also realize that many people don't agree with me, objecting that I make photography more complex than it really is. I have heard this argument before. My answer is that photography is as simple or complex as you make it. Nothing is simpler than taking a snap and producing a recognizable picture. On the other hand, few things demand as much talent, knowledge, devotion, sacrifice, and plain hard work as making significant photographs, pictures that people remember.

To those who say that nobody could possibly consider all the points I raised in this book each time he wants to make a photograph, I answer: Of course not. But neither does a writer recapitulate in his mind an encyclopedia or a dictionary each time he sits down to start a new novel, because a good writer knows his subject, his words and synonyms, his grammar and his spelling, just as a good photographer knows all the factors to be considered before he makes a picture. How do they know? Because they have learned their craft—from life, from personal experience, from other people's work, from studying books on the subject. *The Perfect Photograph* is such a book.

Here, I have assembled everything I consider important for making good photographs. (Notice the emphasis on *good*; to produce recognizable photographs, all a photographer needs to know is already contained in the manufacturer's instructions that accompany every new camera, exposure meter, speedlight, package of film, and developer.) I realize that much of what I say is theory, the gist of which may often prove difficult, and sometimes impossible, to apply in practice. But this does not diminish its value. Theory deals with fundamental concepts, and it is only on the basis of fundamental concepts that anyone can build his own philosophy of photography. To give the reader this basis is the purpose of *The Perfect Photograph*.

I believe that a summary of the contents of this book may be helpful. Key words and sentences are more easily remembered than whole chapters. In this sense, the following points seem particularly important to me:

pp. 12, 62: **A good photograph is the successful synthesis of technique and art.**

pp. 60, 99: **Know-how is worthless unless guided by know-why.**

p. 60: **What matters is not what you photograph, but how you photograph it.**

p. 78: **Photography is *not* a naturalistic medium of rendition.**

p. 80: **Good photographers rely on choice, not chance; they exert control.**

p. 83: **Exerting control in photography means knowing what you do, planning instead of gambling.**

Another vitally important realization is that all the factors that influence the appearance and effect of a picture are inextricably interrelated (pp. 85, 113, 128). A change in one invariably affects several or many of the others. Therefore, they must be considered simultaneously. The time to do this is before the photographer releases the shutter, while there is still time to make changes (pp. 117-118).

The main factors that decide the outcome of a photograph are:

The personality of the photographer (pp. 104, 129–137)
The nature of the subject (pp. 113, 149-162)
The purpose of the picture (p. 120)
The devices and techniques of photography (pp. 162–164)
The audience for which the picture is intended (pp. 164–166)

Making a good photograph is a five-step process involving the following factors (pp. 116–118):

Interest in the subject
Understanding of the subject

168

Evaluation of the subject
Planning the picture
Executing the picture

To be considered good, a photograph must meet the following requirements:

It must have purpose and meaning (p. 120).
It must fulfill its purpose (p. 15).
It must have something worthwhile to say (p. 16).
It must have emotional impact (pp. 16,122).
It must have eye appeal (pp. 16, 124).
It must have graphic qualities (p. 127).

Good pictures are made by making fullest use of the typically photographic qualities, which are:

Authenticity (p. 89)
Sharpness of rendition (p. 89)
Speed of recording (p. 90)
Color translation into black-and-white (p. 91)
Transformation of positive values into negative ones (p. 92)
The semiabstract control processes (pp. 93–94)
Transition from light to dark (p. 94)
The light-accumulating capacity of film (p. 95)
The range from close-up to infinity (p. 95)
The range from wide to narrow angle of view (p. 95)
The ability to create multiple images (p. 96)
Pictures by invisible radiation (p. 97)

Good pictures can be expected only if subject qualities that cannot be rendered directly in the picture are indicated in symbolic form (p. 75). The most important of these qualities are:

Depth (p. 76)
Color in black-and-white photography (p. 77)
Motion (p. 77)
Radiant light (p. 77)

In order to make good photographs, a photographer must have the following qualifications:

The ability to see reality in photographic terms (p. 130)
The ability to observe (p. 132)
The drive to experiment (p. 133)
Enthusiasm and imagination (p. 135)
Phototechnical ability (p. 148)

Immediately before he makes the picture, a good photographer rechecks the following points:

Subject distance and scale (p. 23)
Direction of view (p. 24)
Angle of view (p. 49)
Type and direction of the light (pp. 46–48)
Perspective and distortion (pp. 49–53)
Subject color and color of the light (pp. 53–55)
Subject contrast (p. 56)
Focus and sharpness (pp. 56–58)
Diaphragm and depth of field (p. 86)
Shutterspeed for sharpness or blur (pp. 56–58)
Background (p. 159)
Foreground (p. 160)

A good photographer is one whose main interest is in the subject (p. 116), not in the technicalities of photography, which he uses only as a means to an end—the good picture.

Again and again, I have stressed in this book the interrelationship of all the factors involved in making a photograph. The following diagram shows this relationship in graphic form. The main factor is the *subject*, because it is the reason for making the picture. It acts through the bridge of *vision* and *interest* on the *photographer*, whose function is that of a collector, interpreter, and disseminator of visual information. He, in turn, through *perception, intuition, imagination,* and *mechanical skill*, instills his photograph with *purpose* and *meaning, emotional impact, eye appeal*, and *graphic quality*. If he is successful in this, *technique* will have combined with *art* to convey to the viewer of the picture the *feelings* and *facts* that inspired the photographer to depict the subject.

170

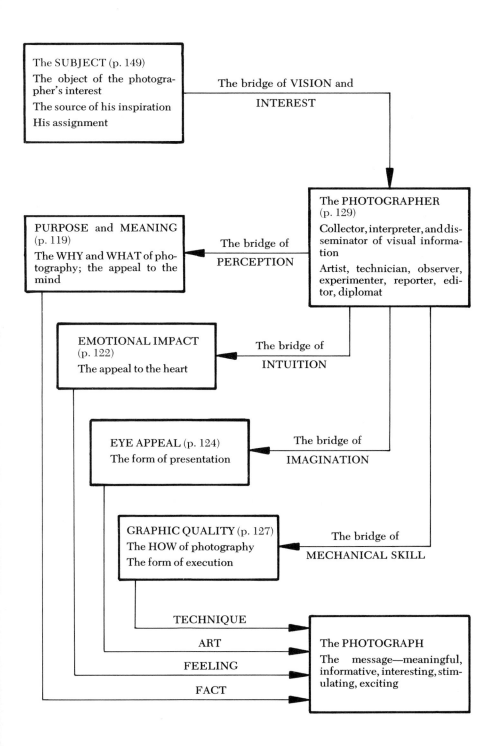

The SUBJECT (p. 149)

The object of the photographer's interest

The source of his inspiration

His assignment

The bridge of VISION and INTEREST

The PHOTOGRAPHER (p. 129)

Collector, interpreter, and disseminator of visual information

Artist, technician, observer, experimenter, reporter, editor, diplomat

PURPOSE and MEANING (p. 119)

The WHY and WHAT of photography; the appeal to the mind

The bridge of PERCEPTION

EMOTIONAL IMPACT (p. 122)

The appeal to the heart

The bridge of INTUITION

EYE APPEAL (p. 124)

The form of presentation

The bridge of IMAGINATION

GRAPHIC QUALITY (p. 127)

The HOW of photography

The form of execution

The bridge of MECHANICAL SKILL

TECHNIQUE

ART

FEELING

FACT

The PHOTOGRAPH

The message—meaningful, informative, interesting, stimulating, exciting

Time out for reflection

Now that I have reached the end of my analysis of what I consider the elements of good photography, I feel it would be in the interest of the reader to take a look at his last batch of pictures with an eye to deciding whether or not he succeeded in what he set out to do. Specifically, he should ask himself the following questions:

Motivation

Honestly—why did I photograph this subject? Did it really interest me, did it turn me on, did I feel moved by it? Or did I shoot it because I had seen and admired similar photographs made by other people, as a result of which I felt that this kind of subject was "the thing"? Or did I act on impulse and shoot it merely because it was there?

Purpose

What did I want my photographs to say? Did I only want to make beautiful pictures? Or did I intend them to be record shots for future reference, snapshots, aids to memory, photographic sketches? Or did I have a more serious purpose in mind when I made these pictures, like showing the viewer what I felt in the presence of my subject—perhaps admiration, compassion, awe, revulsion, pride, or love? Did I try to express the specific characteristics of my subject—beauty, grandeur, squalor, sex appeal? Did I intend my pictures to be educational and informative, or humorous, or just beautiful, or perhaps shocking? As a matter of fact, did I have anything specific in mind at all when I made these pictures?

An honest answer to each of these questions is imperative, because meaningful evaluation of any work is possible only in relation to its purpose. If we do not know what a photographer wanted to say with his pictures, how can we judge whether or not he succeeded?

Reaction

Now, with your photographs in front of you, how do you feel about them? Do you still think the subject was worth the effort? Are you proud of your pictures because you feel they are beautiful, original, effective? Or do they now seem a waste—ordinary, meaningless, too similar to countless other photographs made of similar subjects? Are

172

they photographic clichés? Perhaps you are even secretly ashamed because, no matter how well the pictures came off, you know that they are only copies of someone else's work: Did you show them to other people—your family, friends, other photographers? Did their reactions confirm or refute your own judgments?

Execution

Do your pictures please you in phototechnical respects? Do you feel they are sharp where they should be sharp, unsharp where blur is required, sufficiently contrasty, free of unwanted grain and, if they are transparencies, of satisfactory color? Or are they too grainy and fuzzy? Would they have been better if made on film of larger size? Or with a lens of different focal length from a different camera position, resulting in a different perspective, a different angle of view? And what about the direction and quality of the light? Was the exposure not merely correct (which, today, in the age of photoelectric exposure meters, should be taken for granted), but also was the shutter speed proper for symbolizing motion as you intended, and was the diaphragm aperture the right one for getting a suitable depth of field? Or would a little bit more blur have suggested motion more effectively, or a little less stopping down have given a stronger feeling of depth?

It is this kind of soul-searching that distinguishes the serious photographer from the happy-go-lucky amateur. The first knows that he always has a *choice* of many ways in which to proceed—some of them more suitable to the task at hand than others. The second is satisfied as long as the picture is sharp, the exposure correct, and the subject recognizable.

If the reader wants to photograph the easy way, this book is not for him. As a matter of fact, in that case, he doesn't need *any* book because everything he has to know is already provided by the makers of photographic equipment and supplies in the instructions that always accompany their products.

But if the reader sees in photography more than a pleasant hobby, then, I hope, the preceding discussions will help him to derive more satisfaction from his work. Not that improvement will come overnight. Merely reading this book is not enough. Its contents must be analyzed, accepted, and absorbed until they become part of the intuitive knowledge of the photographer. I have put everything I have to give into this book. How much or how little the reader gets out of it is up to him.

INDEX